POSTCARD HISTORY SERIES

Minneapolis and St. Paul

IN VINTAGE POSTCARDS

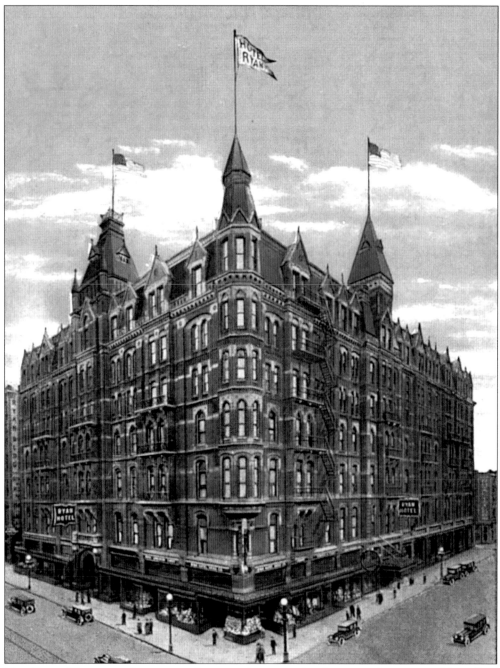

THE RYAN HOTEL, AT SIXTH AND ROBERT STREETS, ST. PAUL. Built at a cost of $1 million and opened in 1885, the seven-story hotel was demolished in 1962. The hotel, designed by James J. Egan, was a Victorian Gothic design. The lot remained vacant for many years until 1981, when the Minnesota Mutual (now Minnesota Life) Insurance Building was built on the site.

Cover Photograph: Please see page 110.

POSTCARD HISTORY SERIES

Minneapolis and St. Paul

IN VINTAGE POSTCARDS

Christopher S. Clay

ARCADIA

Copyright © 2002 by Christopher S. Clay
ISBN 0-7385-1982-0

Published by Arcadia Publishing,
an imprint of Tempus Publishing, Inc.
3047 N. Lincoln Ave., Suite 410
Chicago, IL 60657

Printed in Great Britain.

Library of Congress Catalog Card Number: 2002104761

For all general information contact Arcadia Publishing at:
Telephone 843-853-2070
Fax 843-853-0044
E-Mail sales@arcadiapublishing.com

For customer service and orders:
Toll-Free 1-888-313-2665

Visit us on the internet at http://www.arcadiapublishing.com

In memory of my Father (1927–2002)

He was my greatest source of knowledge and would have been proud of this accomplishment.

Thank you for your love and support Dad and for teaching me about the past.

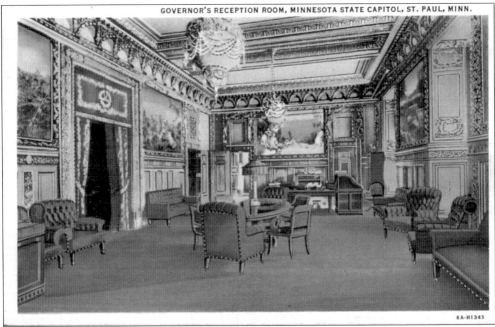

THE GOVERNOR'S RECEPTION ROOM, MINNESOTA STATE CAPITOL, ST. PAUL, C. 1930S.

CONTENTS

ACKNOWLEDGMENTS

I only have one page to thank everyone for his or her support, and unlike most television award shows, I cannot exceed my limit. For starters, thank you to Brent for your generous support, not only in the preparation for this book, but also for the countless hours you afforded me while I sifted through box after box of postcards in antique shops. And of course for the time you allowed me to search away the hours on the Internet seeking the perfect postcard images for my collection. I am especially grateful to the life-long residents of the Twin Cities who shared their memories of times past, including friends, co-workers, and acquaintances I met while working in Downtown St. Paul. In an effort to be as accurate as possible, several facts and dates were confirmed with print and Internet resources which included: *St. Paul: Saga of an American City* by Virginia Brainard Kunz, *Lost Twin Cities* by Larry Millett, and the Minnesota Historical Society website (www.mnhs.org). A special thank you to Joyce Anderson for sharing her time and collection of postcards and literature. And finally to my Mom, for her enduring support during the creation of this book.

INTRODUCTION

Almost 150 years ago on May 11, 1858, Minnesota became the 32nd state of our union. That makes Minnesota and the Twin Cities rather young by comparison to other parts of the nation. The first elected governor of the state was Henry Sibley; hence, many landmarks today (such as schools and streets) bear his name. Three Capitol buildings were constructed, the present one having been built near the turn of the century.

Though still a young state, Minnesota and particularly the Twin Cities of St. Paul and Minneapolis are rich in history. One need only explore the Minnesota History Center in St. Paul or any library and you will find a wealth of information detailing the states history to date.

I arrived in St. Paul (Eagan officially) in April of 1994 when I was transferred with the hotel company I was working for at the time. Not wanting to spend anymore time then I had to living in a hotel room, I quickly searched the region for a place to call home. I decided on a downtown location and chose St. Paul as it would be a much easier commute to Eagan. My first home in the Twin Cities would be Kellogg Square Apartments at Kellogg Boulevard and Robert Street. After a brief departure to Washington D.C. in the summer of 1995, I returned again to St. Paul and took up residence at The Pointe of St. Paul apartments. Then in 1997, my partner and I purchased a home on Saint Paul's East Side near Lake Phalen. In late 2000, we moved to Vermont to own and operate The Stone Hearth Inn located in Chester, a sleepy village of 3,000 in the heart of ski country. The Inn was originally built as a farmhouse around 1810.

It was during my existence in St. Paul that I started my postcard collection, first only buying, then eventually also selling postcards on the Internet. There are virtually thousands of postcard images of the Twin Cities offering us a glimpse into the past. One of the most interesting features of many a postcard is its ability to make something appear far more inviting than it actually is. This is especially true of older images that were artistic impressions or renderings. In many instances in this book, you will find multiple images of the same building or location that highlights this contrast.

Minnesota first became a territory in 1849. St. Paul was established the same year and Minneapolis three years later in 1852. In the late 1800s and early 1900s, much of the development came from a few key people. Many of the names are still visible today, either in the buildings named for them, or in memory of their contributions to the cities: Lowry, Hill, Foshay, and Dayton, to name but a few. History has been a bit more preserved in St. Paul, but both cities lost many historic structures in the late 1800s, after the Great Depression, and again during urban renewal projects of the 1960s, 70s, and 80s. By the late 1960s, mostly in St. Paul, it became more difficult to tear something down because it was "old." Fortunately for this reason, when the St. Paul hotel closed in 1979, the building survived for several years until the "community" helped restore the structure in the early 1980s.

The postcard images collected and presented to you cover the time period from around the

early 1900s to the early 1940s. To show contrast, several are included that represent city life in the 1950s and 1960s. It was in the later 1950s and early 1960s that Interstate 94 was built. During construction, many neighborhoods in St. Paul—including the mostly Black area known as the Rondo neighborhood—were destroyed. Most development in the Twin Cities was said to have been done in the name of progress. The interstate highway system now tears through what were once city blocks neighboring the Capitol Building.

This book represents a sampling of everything from street scenes, to historic hotels, to theaters, to transportation, and to several of the popular lakes and parks. Every effort was made to keep the focus broad across both cities, but no doubt, you may find an image missing of your favorite landmark. Unfortunately, this is because I have not yet discovered postcards depicting every street or building.

I started the book with my collection of over 30 images recalling some of the grand hotels both cities were famous for: in Minneapolis, the West, Leamington, Dyckman, Ritz (they're all gone); and in St. Paul, the Ryan, Saint Paul, Saint Francis (only the Ryan was lost). Some of my personal favorites include the Robert Street Scene, the Selby Avenue Tunnel, and a rare image of the Home for Crippled Children at Lake Phalen.

I have a very strong interest in history and appropriate preservation of history in today's society. This personal interest has led me to research and document history about towns in my native state of New Jersey, and eventually other places that I have called home. In some cases, a brief visit to a town sparks my interest to learn more about it. The same can be said of an interesting postcard. I often wonder if a building still stands today; and if it doesn't, why not? When I first discovered a postcard of the Ryan Hotel in St. Paul, it led me on a crusade to learn more about it. The same story repeats itself over and over again in this collection and many others.

It is with great pleasure I present to you *one version* of Twin Cities' history through historic postcard images. I hope it will serve to trigger a happy memory of a time past, or help stir your interest in discovering what the Twin Cities were like some 50 to 100 years ago...

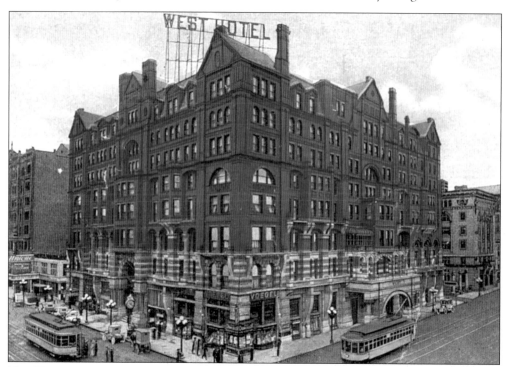

THE WEST HOTEL, MINNEAPOLIS. The Queen-Anne Style hotel opened in 1884 at Fifth Street and Hennepin Avenue.

One
THE HOTELS

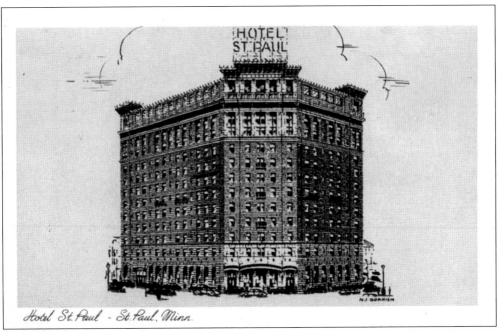

HOTEL ST. PAUL WITH "RENOWNED GOPHER GRILL BARESTAURANT" AND FAMOUS BLACKHAWK HOSPITALITY. The Saint Paul Hotel, as it is known today, is the only grand hotel featured in this book that has survived and continues to operate as a luxury hotel.

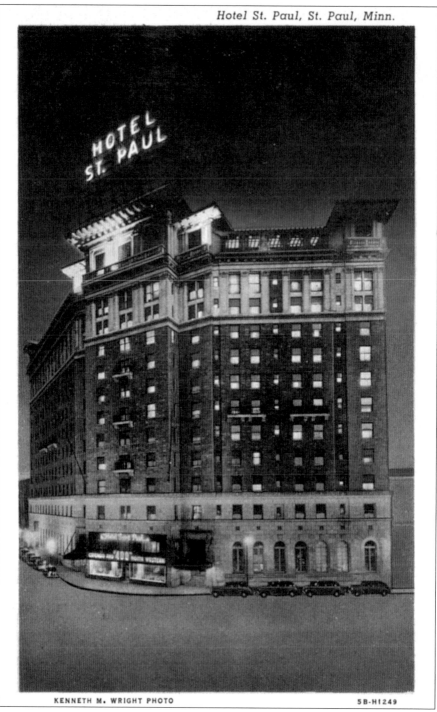

KENNETH M. WRIGHT PHOTO 5B-H1249

HOTEL ST. PAUL, 350 MARKET STREET (BETWEEN FOURTH AND FIFTH STREETS), ST. PAUL. The "Saint Paul" opened in 1910, financed largely in part through the dedication of Lucius Ordway. The hotel is Minnesota's only four-star and four-diamond hotel and resides opposite Rice Park and the Ordway Theatre.

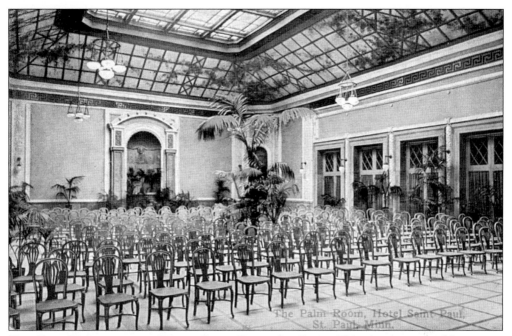

THE PALM ROOM AT THE HOTEL SAINT PAUL, ST. PAUL. This vintage postcard image was postmarked from the West Side Station in St. Paul on June 23, 1913.

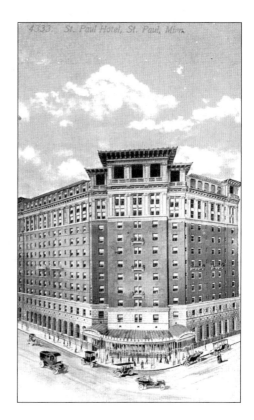

HOTEL ST. PAUL, ST. PAUL, MINNESOTA. The Hotel Saint Paul guest list included Herbert Hoover, Carol Burnett, and Margaret Thatcher, to name a few. This image from the early 1900s was postmarked in 1915.

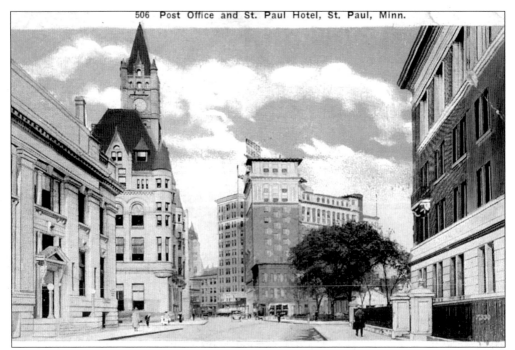

THE ORIGINAL POST OFFICE AND ST. PAUL HOTEL, FROM FIFTH STREET, ST. PAUL. This is one view that has changed very little in the St. Paul landscape.

PARK AT ABERDEEN HOTEL, AT SELBY AND VIRGINIA AVENUES, ST. PAUL, C. 1920. The hotel was constructed in the late 1880s at a cost of $250,000.00, served as a Veteran's Hospital in the 1920s, and was destroyed in the early 1940s.

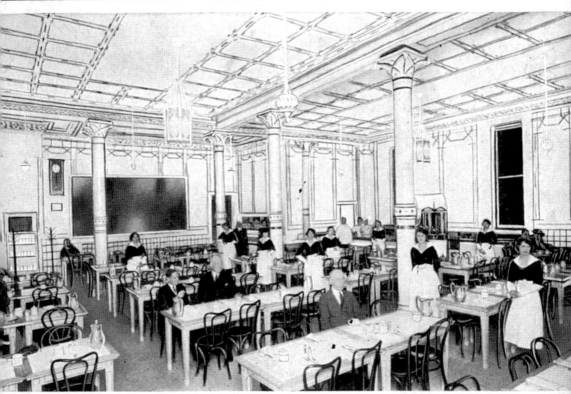

HOTEL RYAN COFFEE SHOP, ST. PAUL, MINN.

HOTEL RYAN COFFEE SHOP, ST. PAUL. An early 1900s glimpse inside the famous hotel, this postcard boasts: "In the Heart of St. Paul, Known for Good Food, Management, A.D. Darge." The constitutional meeting of the Norwegian-American Historical Association was held at the Ryan Hotel on February 3, 1926. Most interesting about this image is that there are no less then ten staff people for the four or five dining guests.

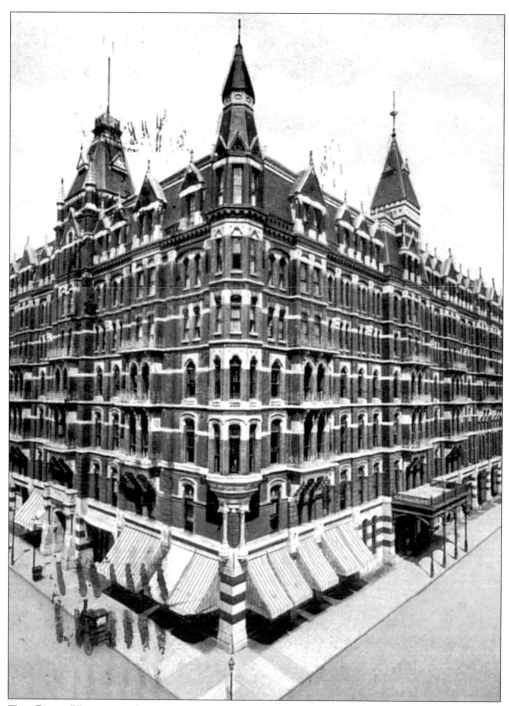

THE RYAN HOTEL, AT SIXTH AND ROBERT STREETS, ST. PAUL. This image was postmarked from St. Paul on April 13, 1909. Built near 1885, two years after the West Hotel opened in Minneapolis, The Hotel Ryan was St. Paul's answer for a luxury hotel, and the Ryan served that need well for most of its years before declining to newer competition. The hotel would suffer the fate of the wrecking ball in 1962. (See another image on page 2.)

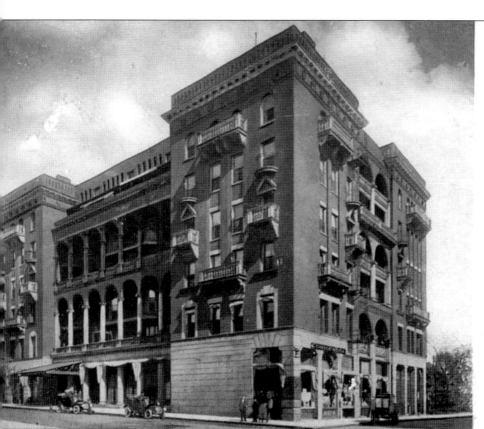

THE WILLA
HOTEL
ST, PAUL, M

THE WILLARD HOTEL, 538 ST. PETER STREET (BETWEEN TENTH AND ELEVENTH STREETS), ST. PAUL. When folks think of the Twin Cities' great hotels, the Willard never seems to come up in conversation. I know very little, except that *most* of the structure itself survived and is in mixed use today (the building is home to Babani's Kurdish restaurant). One thing is certain: the building is shorter by as many as two stories today, and I am guessing this is a result of a tremendous fire that occurred in 1955. I shot a photo in 2000 that shows only four stories (where windows existed on the fifth floor is now brick, and the sixth floor, well, it's gone). Some may recall this structure as the Colonnade Apartments or Willard Apartment Hotel.

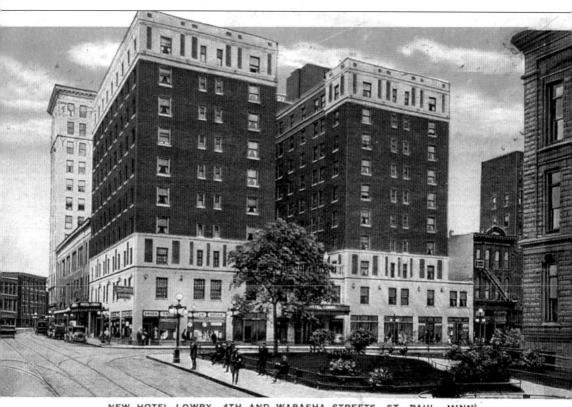

NEW HOTEL LOWRY, 4TH AND WABASHA STREETS, ST. PAUL, MINN.

NEW HOTEL LOWRY, AT FOURTH AND WABASHA STREETS, ST. PAUL. From the late 1920s through the early 1930s, the hotel claimed to be the largest in St. Paul, with rates of $2.00 to $4.00 per day. One postcard describes the hotel: "A modern fireproof commercial hotel. Five

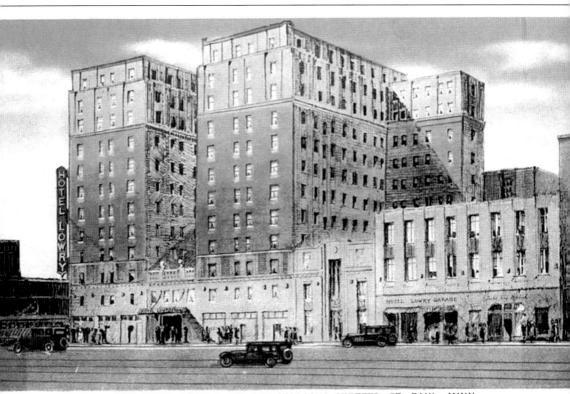

NEW HOTEL LOWRY, 4TH AND WABASHA STREETS, ST. PAUL, MINN.

blocks on direct streetcar line from Union Railway station. Every room has private bath and circulating ice water." The hotel survived and today is known as the Lowry Square Apartments. There has even been "talk" in the city of possibly converting the old building back to a hotel.

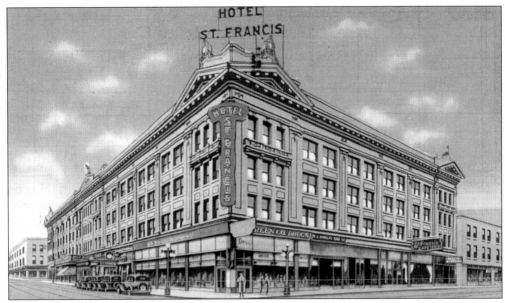

THE SAINT FRANCIS HOTEL, ST. PAUL, C. 1920S. This postcard describes the hotel as "completely refurnished, redecorated, modern and fireproof." You can see signs for the Walgreen Company Drugs and St. Francis Cafeteria on the street level. Today, a Walgreens store still operates across the street. The street level is now home to Bruegger's Bagels and Candyland. Rumor has it that the St. Francis was a hangout for crooks and gangsters in the late 1920s and 1930s.

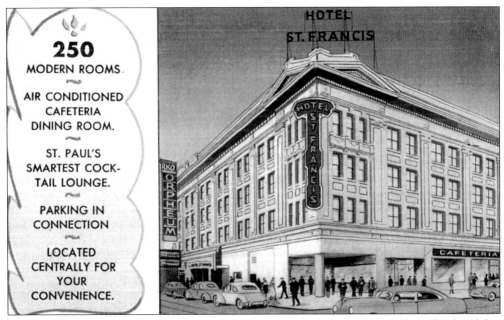

250
MODERN ROOMS.

AIR CONDITIONED
CAFETERIA
DINING ROOM.

ST. PAUL'S
SMARTEST COCK-
TAIL LOUNGE.

PARKING IN
CONNECTION

LOCATED
CENTRALLY FOR
YOUR
CONVENIENCE.

HOTEL ST. FRANCIS, AT SEVENTH AND WABASHA STREETS, ST. PAUL. The hotel has currently survived the wrecking ball and today serves as affordable downtown apartments. The structure houses the (second) Orpheum Theatre, for years sitting vacant and in disrepair. It is believed the foundation was damaged when nearby buildings were demolished for new construction. Underground, another world once existed with retail shops and a hair salon.

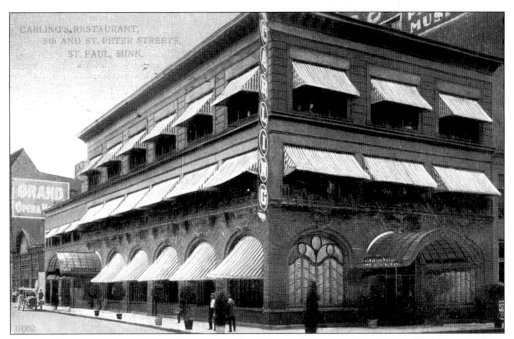

CARLING'S RESTAURANT, AT FIFTH AND ST. PETER STREETS, ST. PAUL. This image of the downtown restaurant dates to the early 1900s and was postmarked in 1909. Today the corner of Fifth and St. Peter is home to a new restaurant, Pazzaluna.

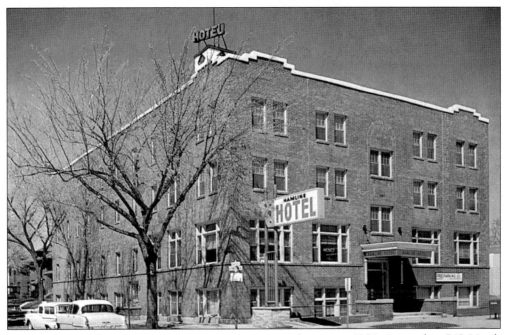

THE HAMLINE HOTEL, 545 NORTH SNELLING ST. PAUL, C. 1955. Located at 545 North Snelling in the heart of the "midway," this image dates to 1955. Typical of the use of many older hotel buildings, today the sight is home to the Wilder Apartments with 132 single-room units.

19

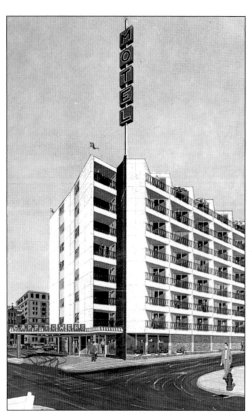

THE CAPP TOWERS MOTEL, NINTH AND MINNESOTA STREETS, ST. PAUL, C. 1960. Another "modern" motel, the Capp Towers, a member of the Best Western Motels, was conveniently located in the Heart of the Loop near Shopping Center, churches, and theatres. The motel also boasted a unique Fire House Café and Cocktail Lounge. Today, the structure serves as the Naomi Family Clinic and sits beside the towering Pointe of St. Paul apartments.

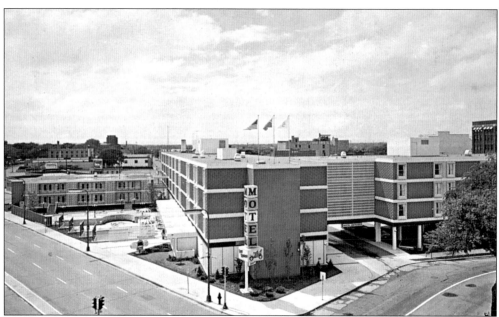

THE INN TOWN MOTEL, AT TENTH STREET AND HAWTHRONE AVENUE, MINNEAPOLIS. This 1950s chrome postcard shows off the 199-room motel, a member of the Kahler Corporation.

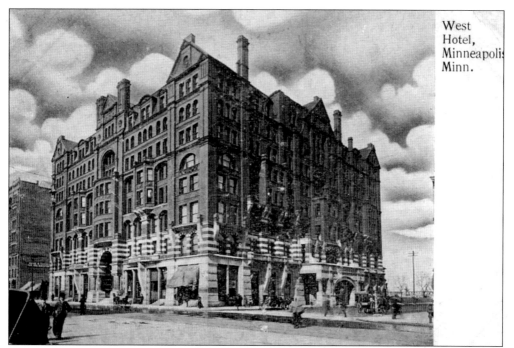

West
Hotel,
Minneapolis,
Minn.

THE WEST HOTEL, AT FIFTH STREET AND HENNEPIN AVENUE, MINNEAPOLIS, C. 1900.
This hotel opened in 1884 with over 400 rooms. The hotel would not survive progress and was demolished in 1940.

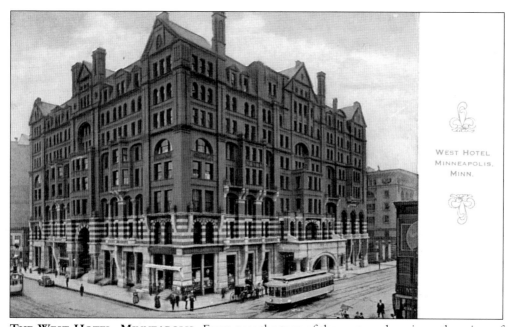

WEST HOTEL
MINNEAPOLIS,
MINN.

THE WEST HOTEL, MINNEAPOLIS. From near the turn of the century, here is another view of the hotel (Hennepin Avenue is to the left). It is fitting that a streetcar appears in this image, since the streetcar mogul Thomas Lowry was one of the businessmen that helped see that the West Hotel was built.

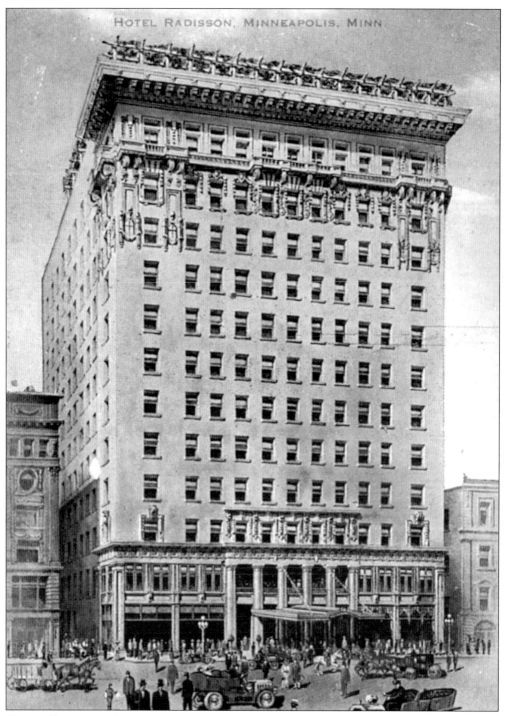

HOTEL RADISSON, MINNEAPOLIS, MINN.

HOTEL RADISSON, LOCATED ON SEVENTH STREET BETWEEN NICOLLET AND HENNEPIN AVENUES, MINNEAPOLIS, C. 1910S. Opened in 1909, the 435-room hotel was named after the 17th-century French explorer, Pierre Esprit Radisson. This hotel closed in 1981, and was demolished in 1982. A new Radisson Hotel was built and opened on the same location in 1987.

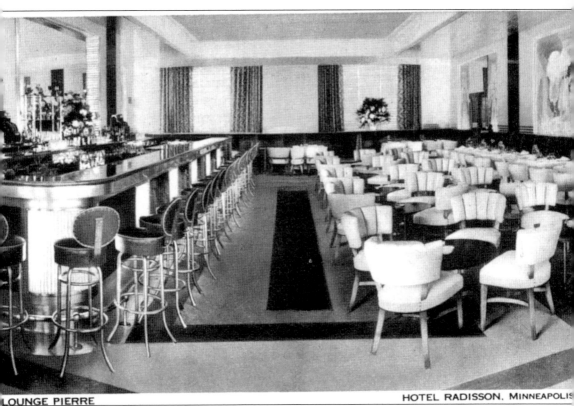

LOUNGE PIERRE HOTEL RADISSON, MINNEAPOLIS

LOUNGE PIERRE, HOTEL RADISSON, MINNEAPOLIS. This postcard remarked on Radisson's "house of quality, hospitality and service." The hotel featured a telephone and cold running water in every room.

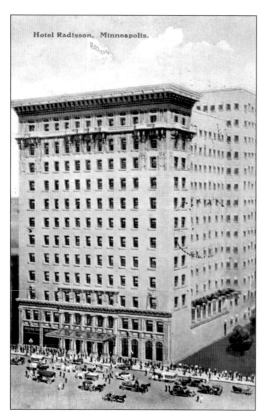

RADISSON HOTEL, MINNEAPOLIS. Here is another image from the 1910s from a slightly different angle. From the mid 1920s through 1940s, one of the broadcast locations of KSTP Radio was the Radisson Hotel.

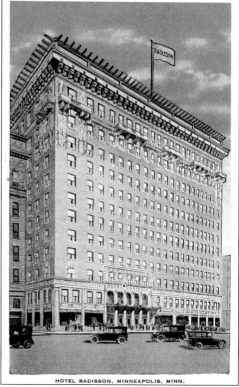

HOTEL RADISSON, MINNEAPOLIS. This postcard from the 1910s or 1920s shows an unusually larger hotel then most postcards depict. Was it some sort of artist rendering for a building that was never built?

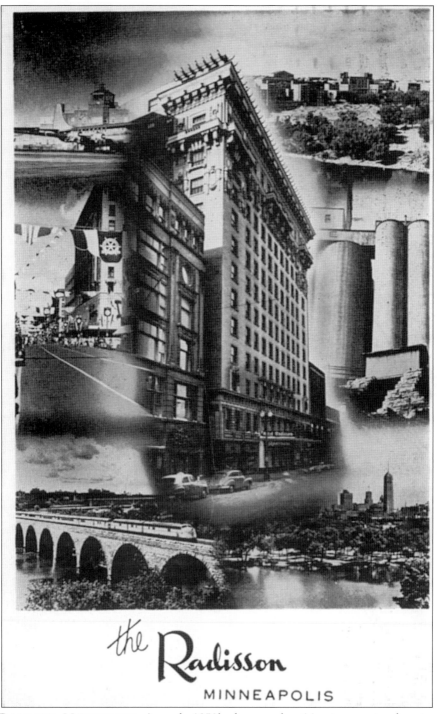

THE RADISSON, MINNEAPOLIS. An early 1950's chrome advertising type postcard captures the Radisson Hotel as the center of Minneapolis business and tourism. Curt Carlson purchased the hotel in 1962, and eventually expanded the Radisson name through hotels around the Twin Cities and eventually across America.

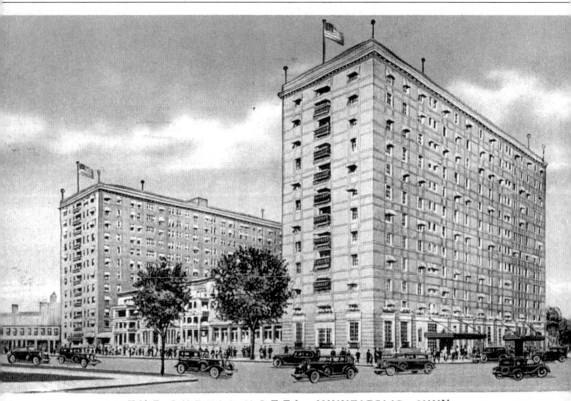

THE CURTIS HOTEL, MINNEAPOLIS, MINN.

THE CURTIS HOTEL, LOCATED ON TENTH STREET BETWEEN THIRD AND FOURTH AVENUES SOUTH, MINNEAPOLIS. Built near the turn of the century, the Curtis advertised itself as "Largest in Northwest." This image of the 800-room hotel was postmarked in 1935. The Curtis Hotel closed after a long run and was demolished in the early 1980s.

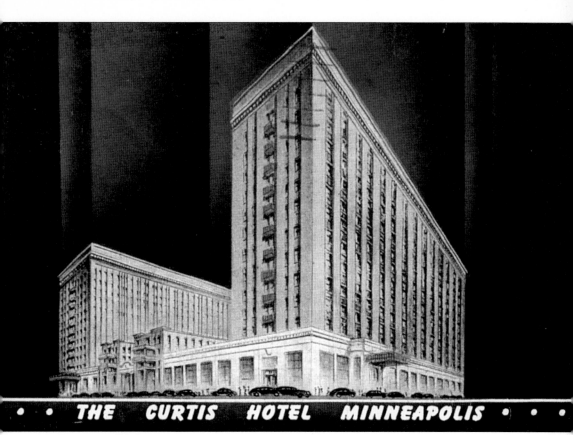

THE CURTIS HOTEL, MINNEAPOLIS, C. 1940S. The hotel featured a drugstore, ballroom, restaurant, and lounge.

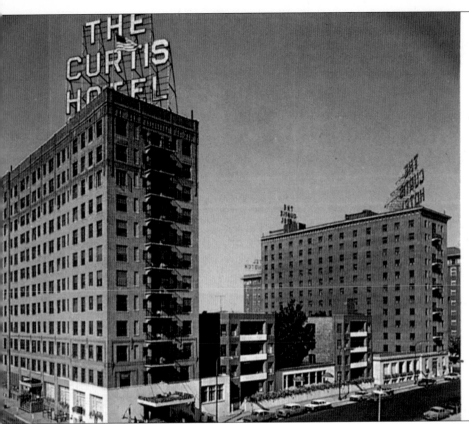

THE

CURTIS

HOTEL

MINNEAPOL
MINNESOTA

THE CURTIS HOTEL, MINNEAPOLIS. Part apartment building, part hotel, this 1950's view shows the various buildings that made up the Curtis Hotel "complex," if you will. In 1956, aerialists with the Shrine Circus performed on the rooftop of the hotel.

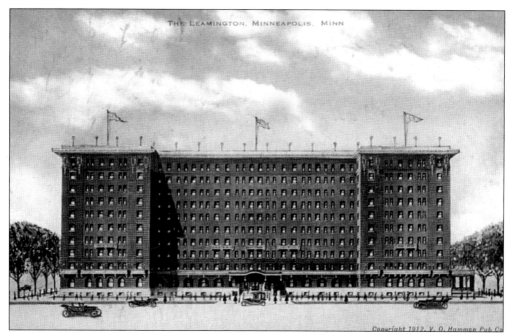

Copyright 1912. V. O. Hammon Pub Co

THE LEAMINGTON, AT TENTH STREET AND THIRD AVENUE, MINNEAPOLIS, C. 1912. This large hotel was built around 1910 and demolished around 1990, replaced by a parking garage (which bears its name). The guest list included John. F. Kennedy, Jimmy Carter (in 1978), and Vice-President Nixon (who held a press conference at the Leamington in September of 1960). This postcard includes a hand-written note: "this is an apartment building with 800 rooms".

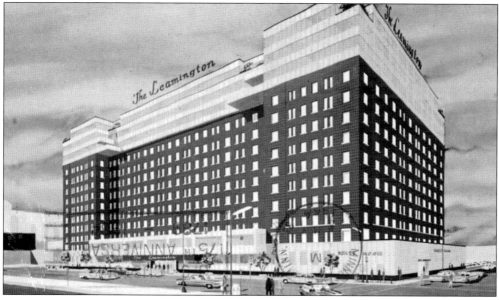

THE LEAMINGTON, MINNEAPOLIS. A modernized image from the late 1950s or early 1960s remarks: "the upper Mid-West's largest, finest, most complete, 100% central air-conditioned luxury hotel with 800 rooms, suites and penthouses. All with private bath, television, radio and musak. Groups from 10 to 6000." The Personal note reads: "Something doing all the time."

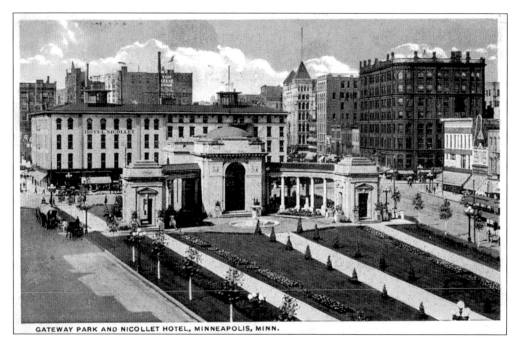

GATEWAY PARK AND NICOLLET HOTEL, MINNEAPOLIS, MINN.

GATEWAY PARK AND NICOLLET HOTEL, MINNEAPOLIS. Originally constructed in the late 1850s and demolished in 1923, a new hotel was built on the same site. This image of the original Nicollet Hotel dates to the 1910s.

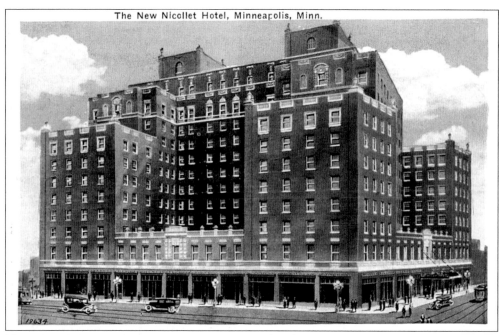

The New Nicollet Hotel, Minneapolis, Minn.

THE NEW NICOLLET HOTEL, MINNEAPOLIS. After the original Nicollet Hotel (or Nicollet House, as some remember it) was demolished, this new 12-story, 637-room hotel was erected. This postcard indicates it was built at a cost of $3.5 million with Minneapolis' capital. Like the first hotel, this one was also demolished, in 1991.

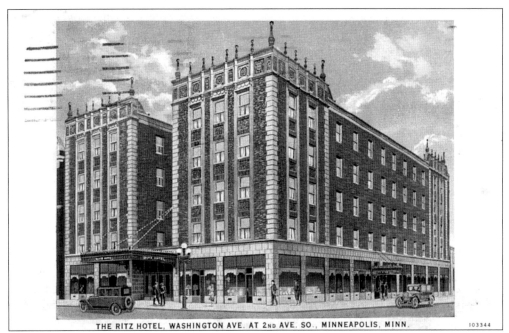

THE RITZ HOTEL, WASHINGTON AVE. AT 2ND AVE. SO., MINNEAPOLIS, MINN. 103344

RITZ HOTEL, ON WASHINGTON AVENUE AT SECOND AVENUE, MINNEAPOLIS, C. 1920S.
Also known as The Minnesotan for many of its years, the 200-plus-room hotel was demolished
in the 1970s. This postcard boasted rates of $1.00 to $1.50 for a room with running water, or
$1.50 to $3.00 for a private bathroom. A. Christopher was the manager when this image was
produced.

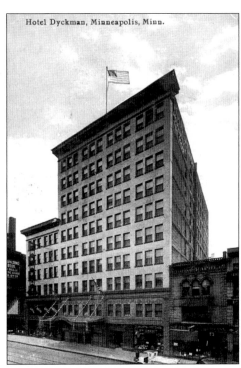

Hotel Dyckman, Minneapolis, Minn.

**HOTEL DYCKMAN, LOCATED ON SIXTH
STREET BETWEEN HENNEPIN AND
NICOLLET AVENUES, MINNEAPOLIS.** The
hotel opened in 1909, featuring private
bathrooms. The hotel was demolished in later
years and replaced by what is now known as
City Center. This image was postmarked from
Minneapolis in 1912.

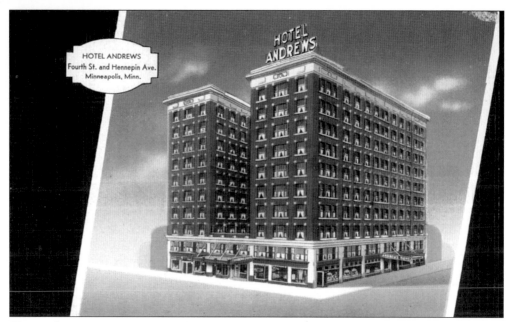

HOTEL ANDREWS, AT FOURTH STREET AND HENNEPIN AVENUE, MINNEAPOLIS. Originally built as a five-story structure around 1910, four additional floors were added early in the hotel's life. Like the Dyckman, the Ritz, the Nicollet, the Curtis, the Leamington, the Radisson and the West Hotels, the Andrews too fell to the wrecking ball in the 1980s.

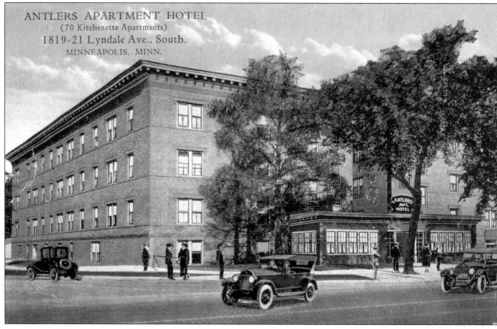

ANTLERS APARTMENT HOTEL AT 1819–21 LYNDALE AVENUE SOUTH, MINNEAPOLIS, C. EARLY 1900S.

Two
STREET SCENES,
BRIDGES, & STREETCARS

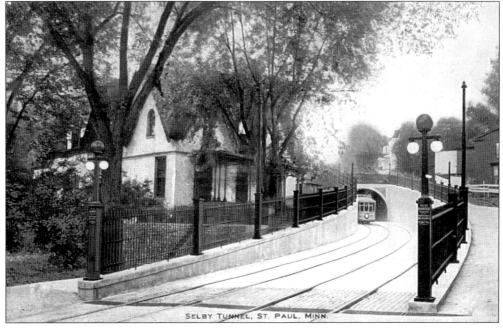

SELBY TUNNEL, ST. PAUL, MINN.

THE SELBY AVENUE TUNNEL, ST. PAUL, C. 1910. Thomas Lowry, who was a part of many development projects in the Twin Cities, formed the Twin City Rapid Transit Company in the 1890s. When the tunnel was completed in the early 1900s, streetcars could travel from downtown up to Selby Avenue. Remnants of the tunnel and tracks still exist today.

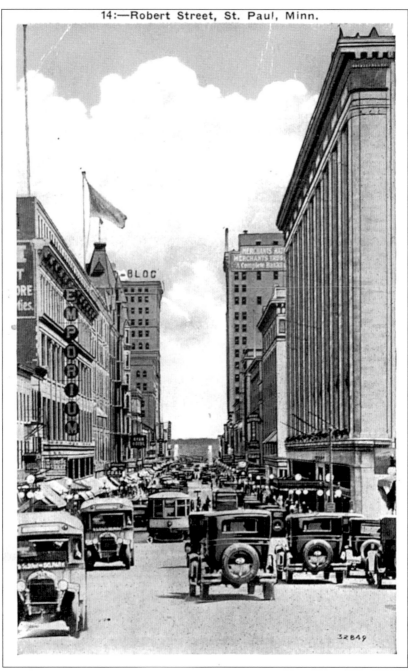

14:—Robert Street, St. Paul, Minn.

ROBERT STREET, ST. PAUL. A major roadway then (and now), this image from the early 1900s looking south shows the Emporium and Ryan Hotel on the left, with Merchants Bank and the Golden Rule Buildings on the right. Although not visible in this image, Woolworth's became part of the downtown scene in the 1950s, with a location at Seventh and Minnesota Streets, directly beside the Golden Rule building. Although the store still stands (vacant) today, demolition is eminent. In 2000, you could still see the tiled entryway with the F.W. Woolworth lettering on Minnesota Street.

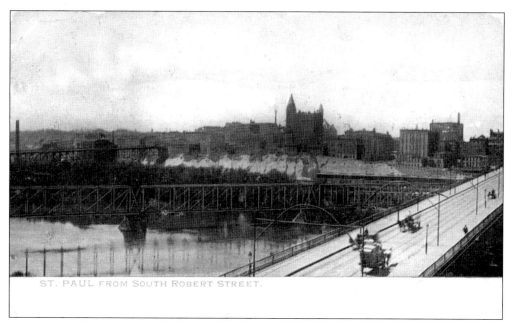

ST. PAUL FROM SOUTH ROBERT STREET.

ST. PAUL FROM SOUTH ROBERT STREET. Postmarked in 1906, the image, possibly from the very late 1890s, shows horse drawn carriages crossing the Robert Street bridge.

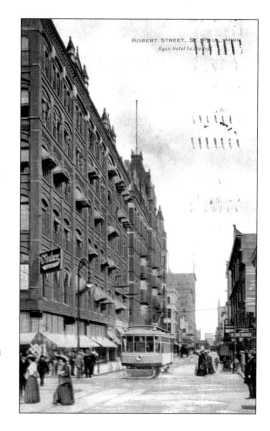

ROBERT STREET, ST. PAUL, C. EARLY 1900s. This postcard shows a busy street with a streetcar and Ryan Hotel to the left. By 1920, automobile and streetcar traffic increased significantly and plans were laid to widen Robert Street.

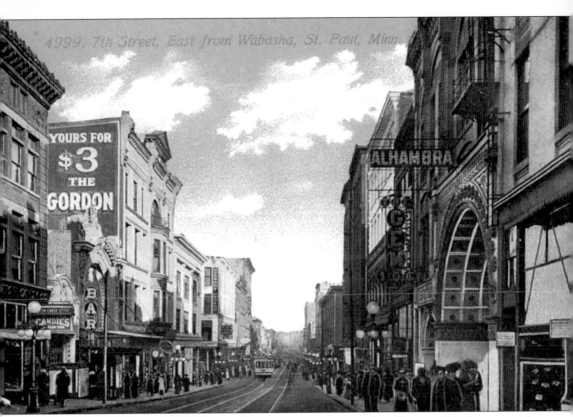

SEVENTH STREET, LOOKING EAST FROM WABASHA, ST. PAUL. This image, with a handwritten note in 1911, depicts St. Paul of a bygone era. It is taken from what is now known at the Seventh Place Mall, outside the Seventh Place Apartments (formerly the St. Francis Hotel). The Alhambra Theatre is prominent to the right. Almost everything in this image is gone, replaced by the World Trade Center and Town Square Center.

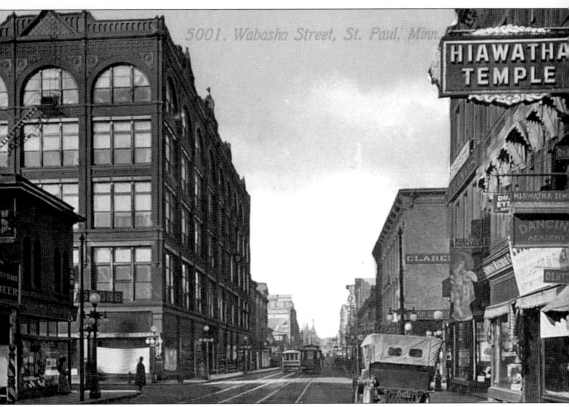

WABASHA STREET, LOOKING NORTH FROM SIXTH STREET, ST. PAUL, C. EARLY 1900S. This image shows the Hiawatha Temple on the right.

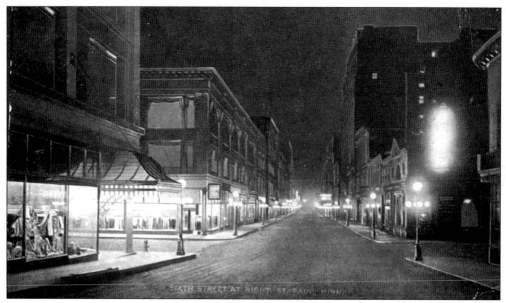

SIXTH STREET, AT NIGHT LOOKING WEST, ST. PAUL, C. 1905. In this dramatic image, we see a very different version of Sixth Street with clothing shops, a Café, and even an Opera House. The Exchange Building is the tall dark building on the right. This landscape changed dramatically through the years, very much so in the 1960s when an entire city block was cleared between Sixth and Seventh Streets for a new Downtown Dayton's Store.

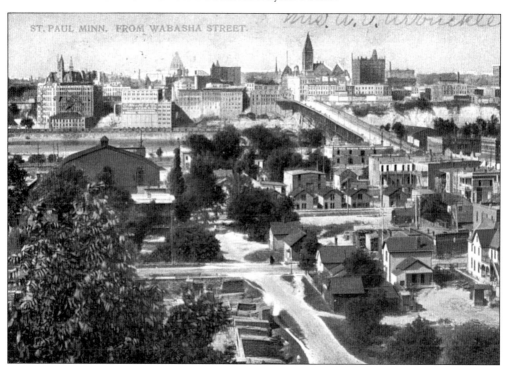

A VIEW ST. PAUL FROM WABASHA STREET. This image from the very early 1900s captures the St. Paul skyline from the west side, or south Wabasha Street as we know it today.

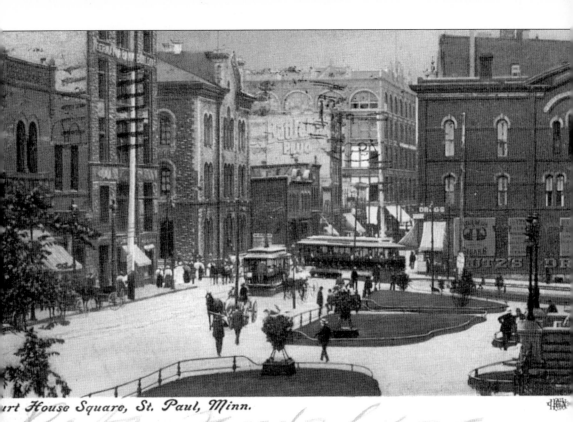

rt House Square, St. Paul, Minn.

COURT HOUSE SQUARE, ST. PAUL, C. 1905. This postcard shows the original Courthouse Square before the new city hall and courthouse was built in the early 1930s. City Hall is to the right, the Germania Bank Building is the taller building on the left.

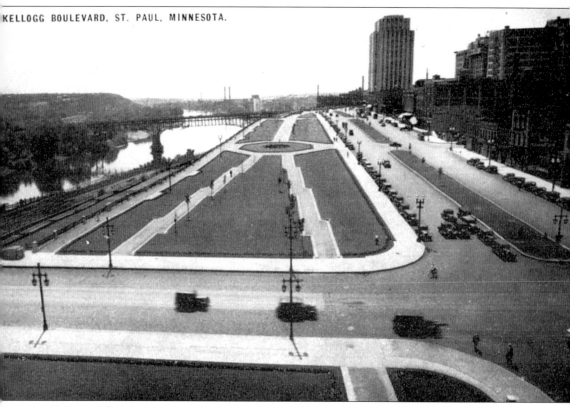

KELLOGG BOULEVARD, ST. PAUL, C. 1930s. This Conoco TOURAIDE postcard depicts an early view of the new Kellogg Boulevard from the intersection of Kellogg and Robert Street. In the late 1920s, most buildings along the south side of Third Street (renamed Kellogg Blvd.) were torn down to widen the street for improved views and better traffic conditions.

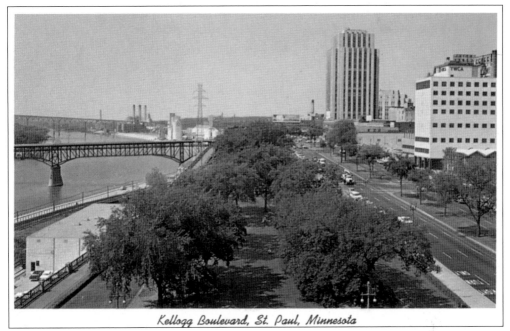

Kellogg Boulevard, St. Paul, Minnesota

KELLOGG BOULEVARD, ST. PAUL, C. 1950S. Progressing to the 1950s, this image captures the new YMCA and new City Hall and Ramsey County Courthouse. The boulevard was named for St. Paul Lawyer Frank Kellogg.

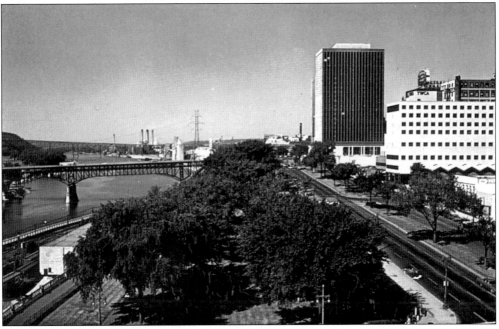

KELLOGG BOULEVARD, ST. PAUL, C. 1960S. This image now includes the new beautiful Hilton Hotel (which fully blocks the City Hall building). The postcard reads: "This beautiful boulevard and parkway skirts the south edge of the loop district." The Kellogg Square Apartment building at Kellogg and Robert has not yet been constructed.

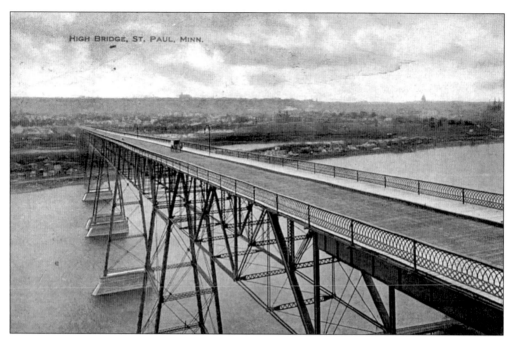

SMITH AVENUE'S HIGH BRIDGE, ST. PAUL. The High Bridge, built in the late 1880s, managed to survive a tornado that severely damaged it in 1904. A new bridge was built in the 1980s. This image postmarked 1910 shows a lone horse-drawn carriage making its way up the bridge to downtown—think about that poor soul the next time you zip across the bridge in your automobile.

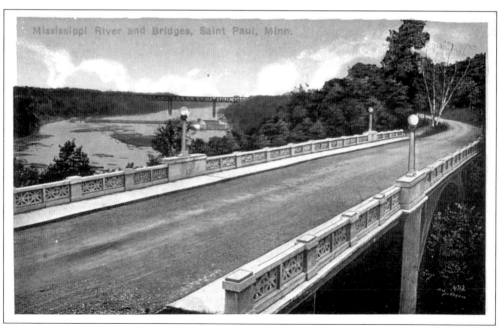

MISSISSIPPI RIVER AND BRIDGES, SAINT PAUL.

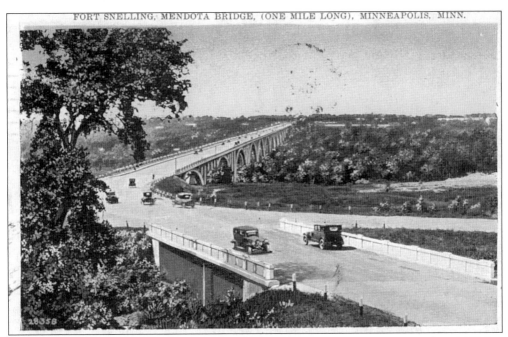

FORT SNELLING-MENDOTA BRIDGE. The bridge built in 1926 and spanning more then 4,100 feet was the largest concrete arch bridge in the world. It was erected at a cost of more then $2 million, is 45 feet wide, and 120 feet tall.

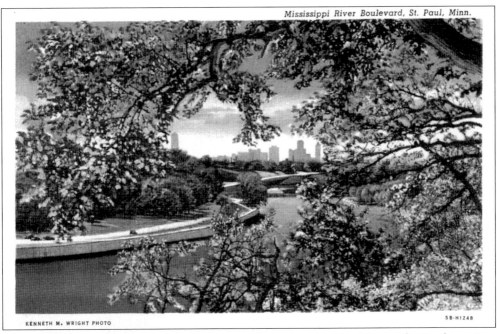

Mississippi River Boulevard, St. Paul, Minn.

KENNETH M. WRIGHT PHOTO

5B-H1248

MISSISSIPPI RIVER BOULEVARD, ST. PAUL. Postmarked in the 1940s, the sender writes: "We're busy rushing around like city people."

SUMMIT AVENUE EAST, ST. PAUL, C. EARLY 1900S. The 4-mile-plus stretch contains some of the most stunning Victorian architecture in the country. The avenue is home to the Governor's Mansion and the 32-room mansion of James J. Hill (1838–1916), builder of the Great Northern Railway.

Take an Auto Ride with me at St. Paul.

"TAKE AN AUTO RIDE WITH ME AT ST. PAUL." I quite honestly do not see a car in this nondescript image, but the sender writes: "Isn't this a great way to go to Chicago?" This card was postmarked in 1907.

University Avenue, Minneapolis.

UNIVERSITY AVENUE, MINNEAPOLIS. Unfortunately, this postcard shares neither a personal note nor imprinted information regarding the specific location in this very early 1900s look at University Avenue.

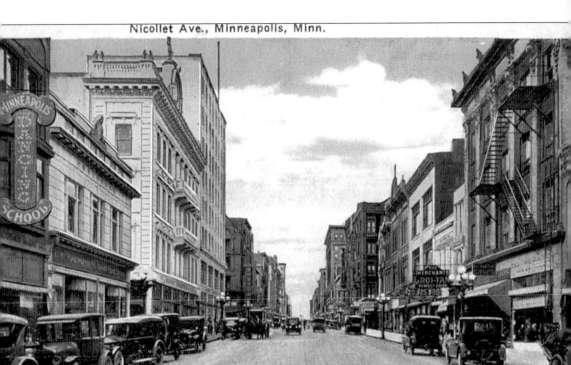

NICOLLET AVENUE, MINNEAPOLIS, C. EARLY 1900S. The Minneapolis Dancing School is to the far left in this image.

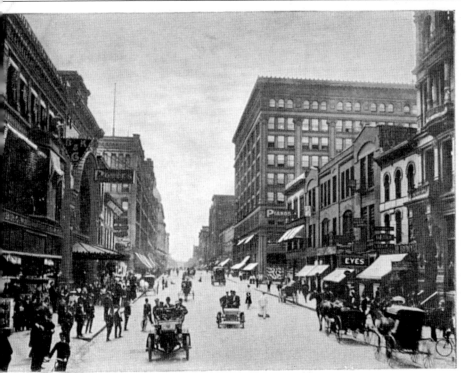

NICOLLET AVENUE, MINNEAPOLIS, MINN.

NICOLLET AVENUE, MINNEAPOLIS, C. 1900. Here, we take a glimpse back at how Nicollet Avenue appeared near the turn of the century.

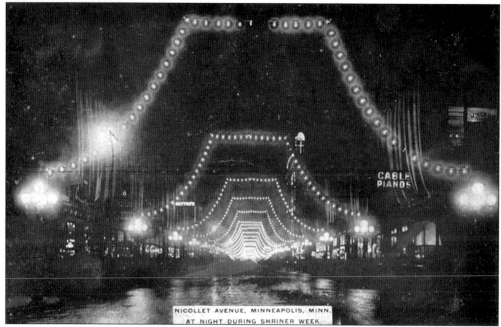

NICOLLET AVENUE, MINNEAPOLIS, C. 1908. This view was taken at night during Shriner Week. A Dayton's Department Store sign is visible in the distance to the left.

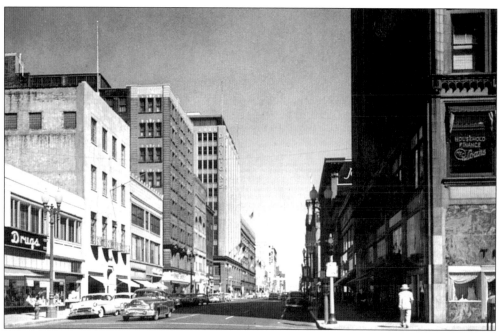

NICOLLET AVENUE, MINNEAPOLIS, C. 1950s. In this image, Dayton's Department store is seen a bit clearer in the distance. Nicollet Avenue would be replaced by Nicollet Mall by the late 1960s, as you will see in the next image. A few years later, Nicollet Mall became famous when Mary Tyler Moore used the pedestrian shopping strip to toss her hat.

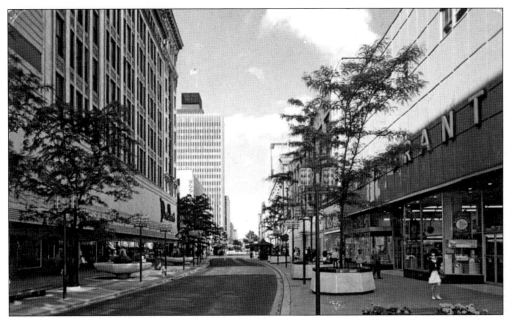

NICOLLET MALL LOOKING SOUTH, MINNEAPOLIS, C. LATE 1960s. This chrome postcard features Donaldson's and Woolworth's on the left and W.T. Grant on the right. The sender writes: "...enjoying our visit here and shopping in the large stores. Lake Harriet is all sparkly with the sun shining on it..."

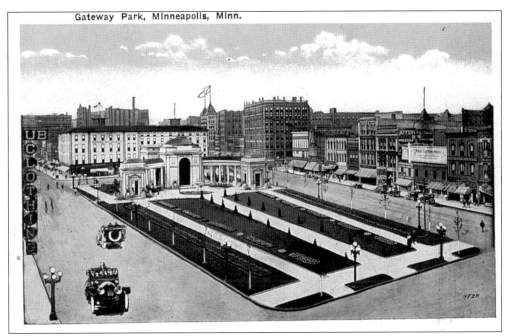

GATEWAY PARK, MINNEAPOLIS, C. EARLY 1900s. This image shows the Hotel Nicollet in the background.

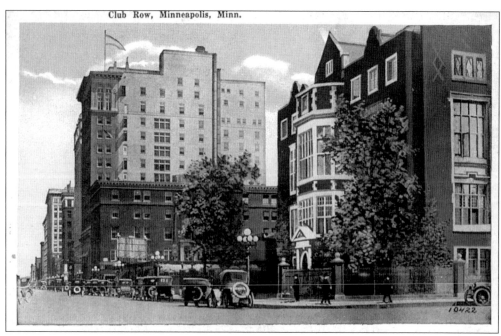

EARLY 1900s CLUB ROW, MINNEAPOLIS. The Minneapolis Club is prominent in the foreground while the Athletic Club stands tall in the background.

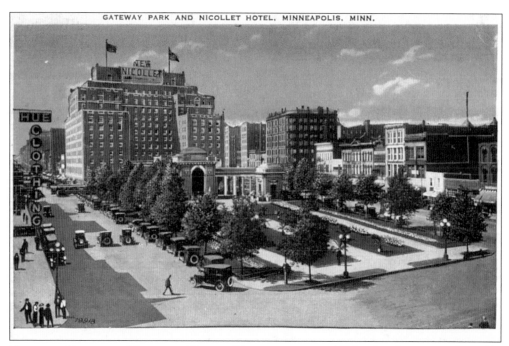

GATEWAY PARK AND NICOLLET HOTEL, MINNEAPOLIS, C. 1930s. Another view of Nicollet Park, this one features the new Nicollet Hotel.

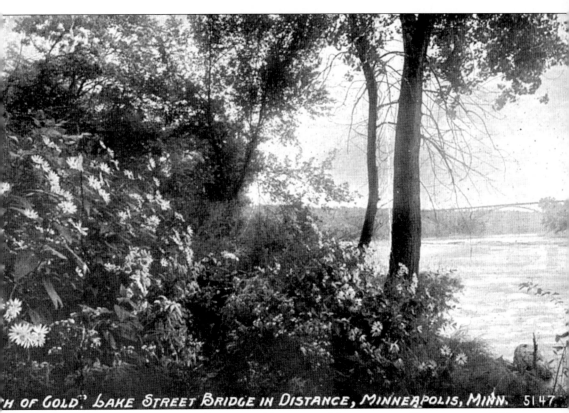

"PATH OF GOLD" LAKE STREET BRIDGE IN DISTANCE, MINNEAPOLIS, MINN. 5147

"PATH OF GOLD" LAKE STREET BRIDGE IN DISTANCE, MINNEAPOLIS, POSTMARKED 1911.

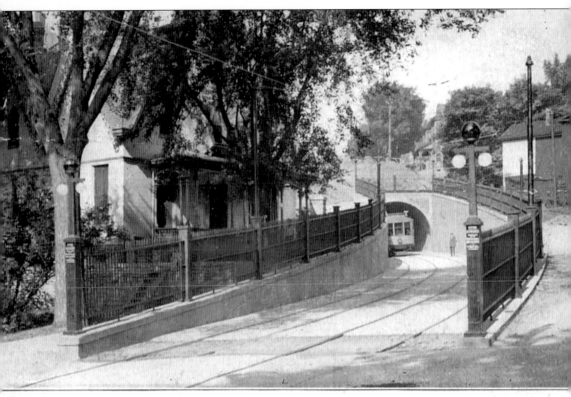

ELBY AVENUE TUNNEL SAINT PAUL PUBLISHED BY HENRY E. WEDELSTAEDT CO., ST. PAUL

SELBY AVENUE TUNNEL, SAINT PAUL, C. EARLY 1900S. The famous streetcars of most American cities were eliminated and eventually destroyed as the automobile from Detroit, and eventually city bus systems, became the popular means of transportation. This wonderful image from yesteryear captures a streetcar disappearing into the nearly 1,500-foot-long tunnel that aided the streetcar in climbing the steep hill. Remnants of the tunnel (built near the turn of the century) remain today. This tunnel became obsolete when the streetcar system was abandoned in favor of buses in the 1950s. Sadly, the streetcars were not saved, and in fact most streetcars and tracks were burned for scrap metal. Several key figures were later indicted for fraudulent activities.

Three
PLACES OF WORSHIP

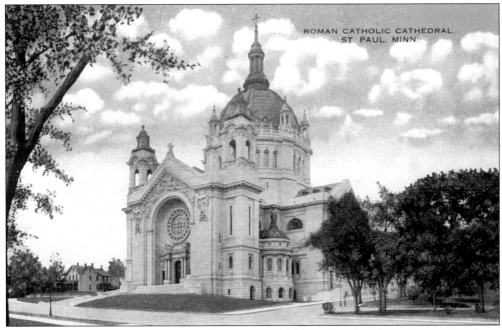

ROMAN CATHOLIC CATHEDRAL, ST. PAUL. Text of the card reads: "Recently completed at a cost of $1,600,000. The successor to the little log chapel from which the city took its name. One of the finest pieces of ecclesiastical architecture in America."

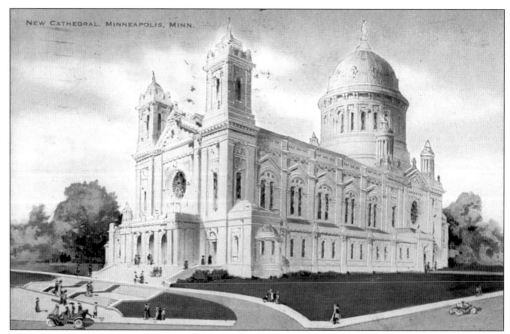

NEW CATHEDRAL, MINNEAPOLIS. This image postmarked in 1912 was likely rendered *before* the cathedral was completed. The cathedral was constructed between 1907 and 1915 and named to the National Register of Historic Places in 1975.

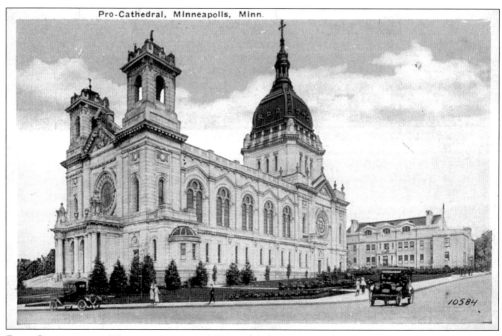

PRO CATHEDRAL, MINNEAPOLIS, C. 1920. This later image shows more accurate details.

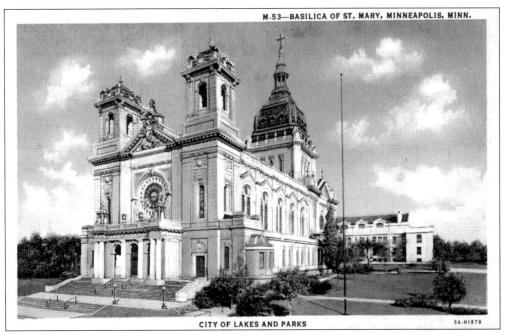

CITY OF LAKES AND PARKS

SA-H1878

BASILICA OF ST. MARY, MINNEAPOLIS, C. 1935.

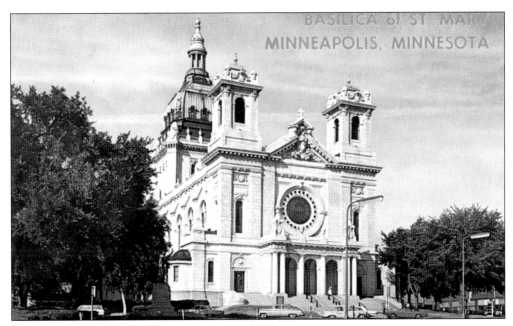

BASILICA of ST. MARY
MINNEAPOLIS, MINNESOTA

BASILICA OF ST. MARY, MINNEAPOLIS, C. 1955.

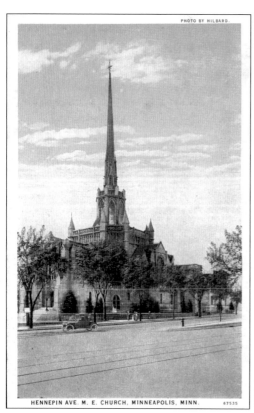

PHOTO BY HILBARD.

HENNEPIN AVE. M. E. CHURCH, MINNEAPOLIS, MINN. 67535

M.E. CHURCH, ON HENNEPIN AVENUE, MINNEAPOLIS.

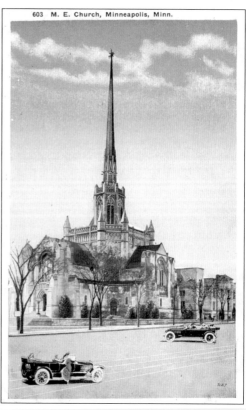

603 M. E. Church, Minneapolis, Minn.

56

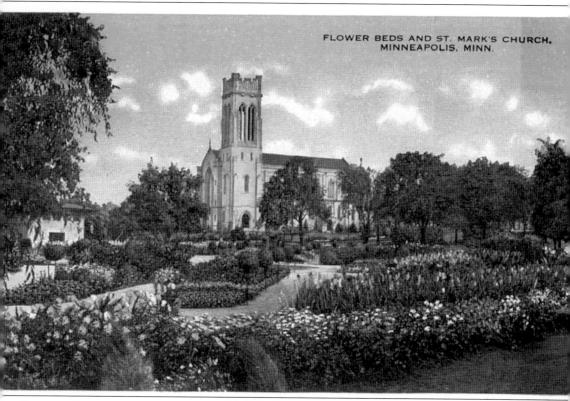

FLOWER BEDS AND ST. MARK'S CHURCH. MINNEAPOLIS, MINN.

FLOWER BEDS AND ST. MARK'S CHURCH, MINNEAPOLIS. As written on the reverse of the postcard: "The Church is located on Lowry Hill, overlooking beautiful Loring Park and the Armory Flower Gardens, which are seen in the foreground."

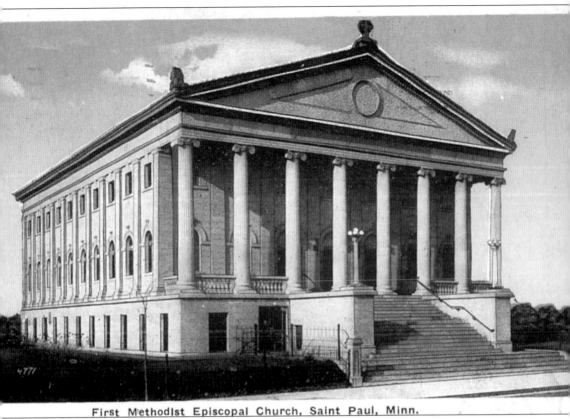

First Methodist Episcopal Church, Saint Paul, Minn.

FIRST METHODIST EPISCOPAL CHURCH, AT PORTLAND AND VICTORIA AVENUE, SAINT PAUL, C. 1910–1920.

INTERIOR VIEW OF ASSUMPTION CHURCH, LOCATED ON WEST SEVENTH STREET NEAR RICE PARK, ST. PAUL. This church is the oldest in St. Paul, having been built during the early 1870s.

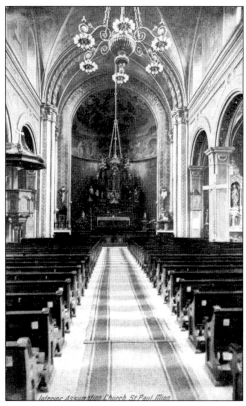

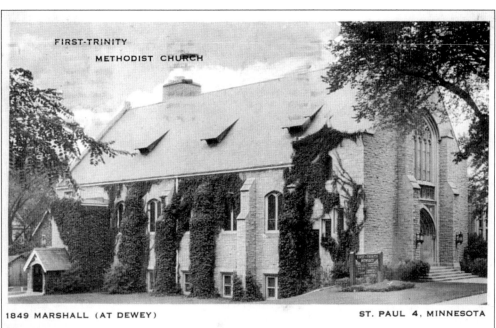

FIRST-TRINITY METHODIST CHURCH, AT MARSHALL AND DEWEY STREETS, ST. PAUL, C. 1950s.

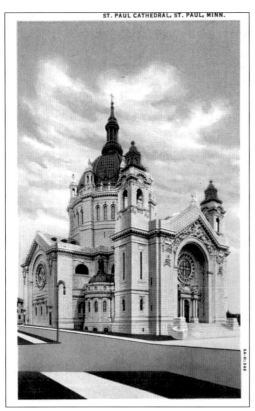

ST. PAUL CATHEDRAL, ST. PAUL, C. 1930s. Through the vision of Archbishop John Ireland, the church (actually the fourth Cathedral of Saint Paul) was constructed between 1906 and 1915. The church was placed on the National Register of Historical Buildings in 1974.

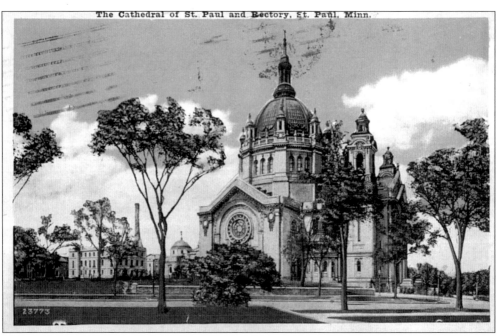

THE CATHEDRAL OF ST. PAUL AND RECTORY, ST. PAUL. This card, postmarked in 1926, remarks on the interior diameter of the dome—96 feet.

Four

THE STATE CAPITOL

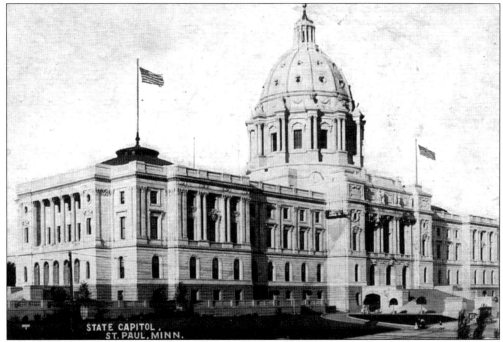

THE MINNESOTA STATE CAPITOL, ST. PAUL. Construction started around the middle 1890s and was completed in 1905. The Italian Renaissance building was designed by Cass Gilbert. This is actually the third Capitol building; the first was located at Tenth and Cedar Streets.

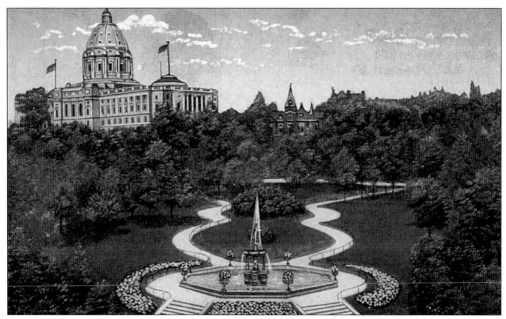

A VIEW OF THE STATE CAPITOL FROM CENTRAL PARK, C. EARLY 1900S.

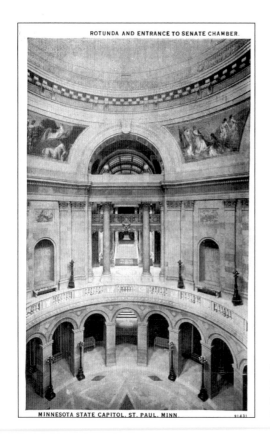

THE MINNESOTA STATE CAPITOL, ST. PAUL, C. 1920S. This image shows the rotunda and entrance to Senate Chamber at the Minnesota State Capitol.

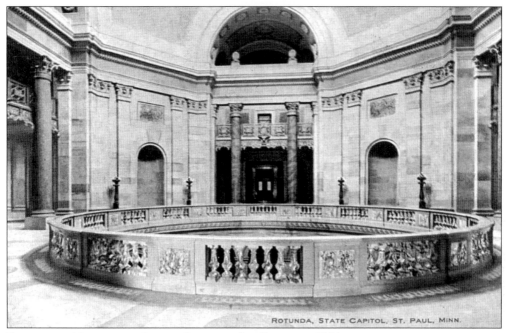

ROTUNDA, MINNESOTA STATE CAPITOL, ST. PAUL, c. 1920.

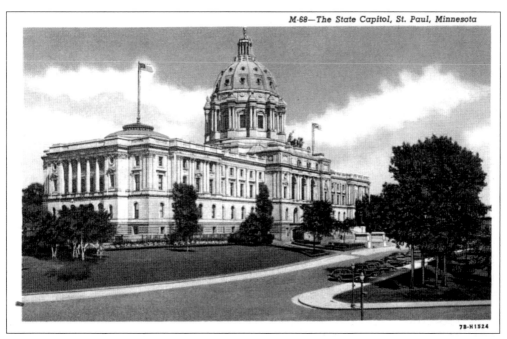

AN EXTERIOR VIEW OF THE MINNESOTA STATE CAPITOL, ST. PAUL, c. LATE 1930s. More than 25 varieties of marble, sandstone, limestone, and granite were used in the construction. The marble dome is said to be one of the tallest in the world.

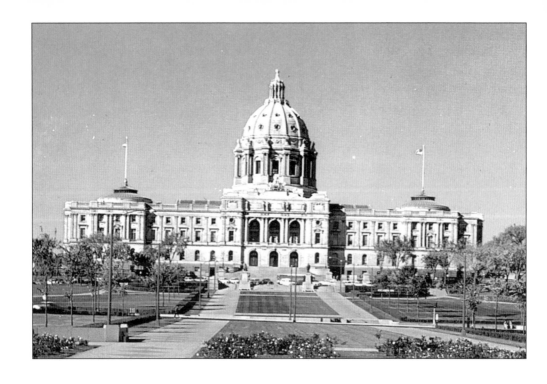

MODERN EXTERIOR VIEWS OF THE MINNESOTA STATE CAPITOL, ST. PAUL, C. 1960S.

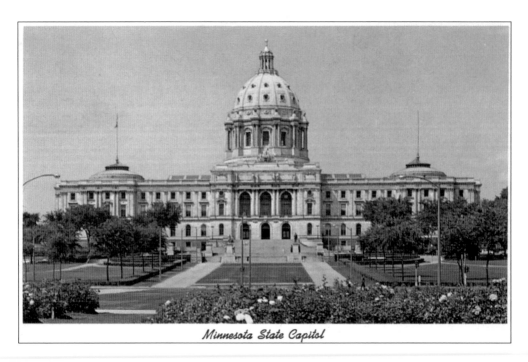

Minnesota State Capitol

Five

AROUND THE CITY
ST. PAUL

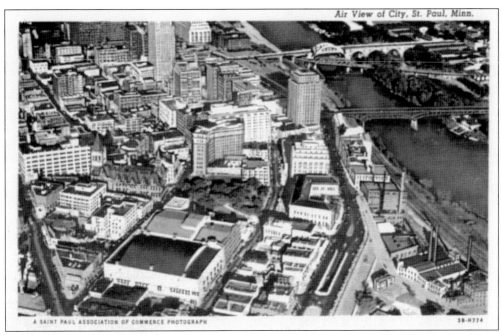

Air View of City, St. Paul, Minn.

A SAINT PAUL ASSOCIATION OF COMMERCE PHOTOGRAPH

AN AERIAL VIEW OF ST. PAUL, C. 1930s. A linen postcard captures a glimpse of St. Paul from above, showing the Municipal Auditorium, St. Paul Hotel, Lowry Building, and City Hall and Ramsey County Courthouse.

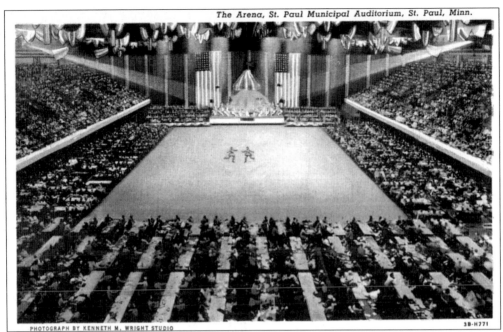

PHOTOGRAPH BY KENNETH M. WRIGHT STUDIO 3B-H771

THE ARENA, ST. PAUL MUNICIPAL AUDITORIUM, ST. PAUL, C. 1930S. This postcard boasted the auditorium's unique entertainment, including figure skating reviews on an artificial ice rink (pictured here). In 1946, the Boys Town Choir sang to a crowd of 9,000 at the auditorium. The Monkees performed here in August 1967. Built in 1907, the original auditorium was demolished in 1982, and the site is currently home to the Ordway Theatre.

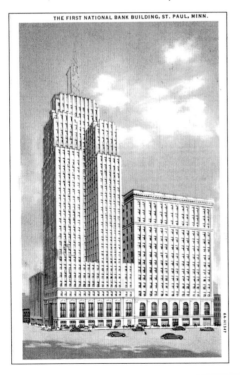

THE FIRST NATIONAL BANK BUILDING, ST. PAUL, MINN.

THE FIRST NATIONAL BANK BUILDING, AT FIFTH AND MINNESOTA STREETS, ST. PAUL. One of the oldest landmarks in the city, the 32-story building, completed around 1930, still stands today with its famous "1st" sign high atop the building.

POST OFFICE BUILDING, ST. PAUL. The original post office building was built around 1902, and also served as the federal courthouse. After a group of citizens saved the building from the wrecking ball in the early 1970s, it reopened as the Landmark Center in 1978. This image was postmarked 1909.

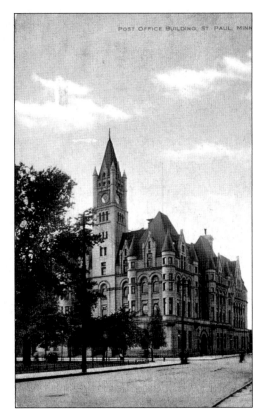

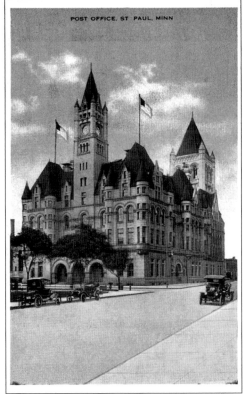

POST OFFICE AND FEDERAL COURTS BUILDING, ST. PAUL, C. EARLY 1900s. As described on this postcard: "Splendid edifice of gray native stone." Like many, this postcard features two "fictional" flags atop the building. For some reason, flags were added where none actually existed before.

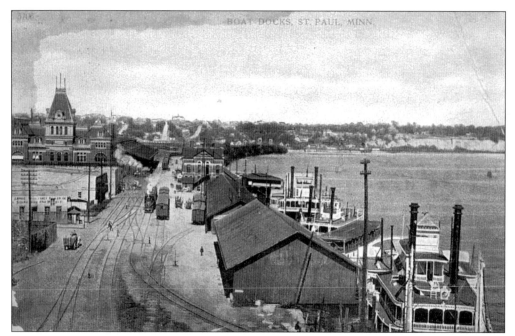

BOAT DOCKS ALONG THE MISSISSIPPI, ST PAUL, C. EARLY 1900s. The Union Depot building is the taller building to the left.

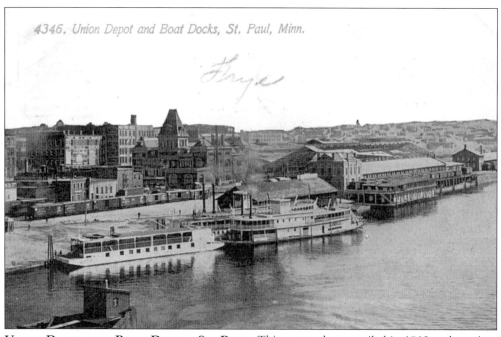

UNION DEPOT AND BOAT DOCKS, ST. PAUL. This postcard was mailed in 1913, a short time before fire would severely damage the Depot building. In the 1930s, the United States Post Office was constructed on the site of the old depot building.

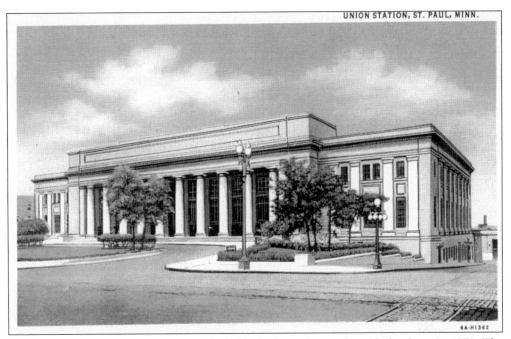

UNION STATION, ST. PAUL. Opened in 1923, the last train ran through the depot in 1971. The depot remained vacant until the 1980s. Residents of the region would see the traveling "Titanic" exhibit and infamous whistle blowing here in February 1999. Today, the station operates as a retail, dining, and business complex.

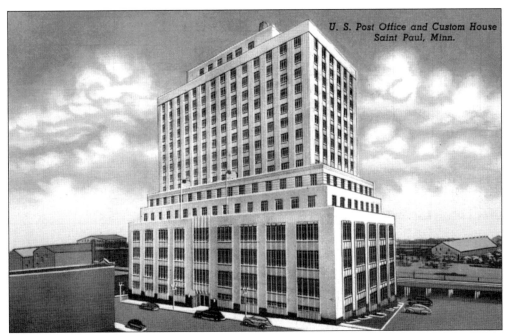

THE NEW U.S. POST OFFICE AND CUSTOM HOUSE, AT THIRD AND JACKSON STREETS, ST. PAUL, C. LATE 1930S. Construction commenced in the early 1930s.

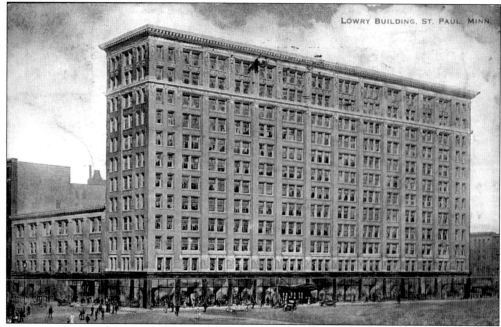

THE LOWRY BUILDING, 350 ST. PETER STREET, ST. PAUL. Still in existence today, this image of the 12-story building was postmarked from St. Paul in 1911, at about the same time construction was completed. Thomas Lowry was a well-recognized name in the Twin Cities from the late 1800s until his death in 1909. A book, Streetcar Man: *Tom Lowry and the Twin City Rapid Transit Company*, was even written about him by his grandson Goodrich Lowry.

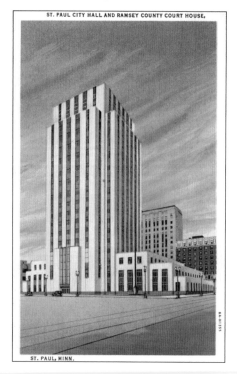

ST. PAUL CITY HALL AND RAMSEY COUNTY COURT HOUSE,

ST. PAUL, MINN.

ST. PAUL CITY HALL AND RAMSEY COUNTY COURTHOUSE, ON KELLOGG BOULEVARD, ST. PAUL. Built between 1930 and 1932, the 21-story building replaced the old courthouse at Fourth and Wabasha Streets, which was demolished around 1933. The current building was listed on the National Register of Historic Places in 1983.

70

CITY HALL AND COURT HOUSE, ST. PAUL. Carl Milles' Indian Statue, "The God of Peace" stands 36 feet high and weighs 60 tons. It was dedicated to the war veterans of Ramsey County.

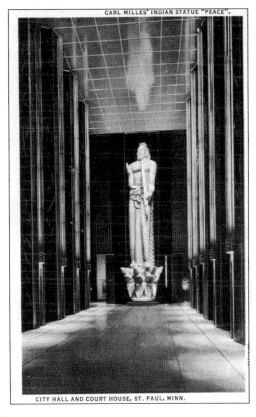

CARL MILLES' INDIAN STATUE "PEACE",

CITY HALL AND COURT HOUSE, ST. PAUL, MINN.

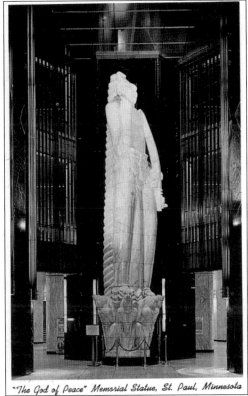

"The God of Peace" Memorial Statue, St. Paul, Minnesota

CITY HALL AND COURT HOUSE, ST. PAUL, C. 1964. The rotating statue turns 66 degrees left and 66 degrees right from center, requiring 2 1/2 hours for the complete 132-degree turn.

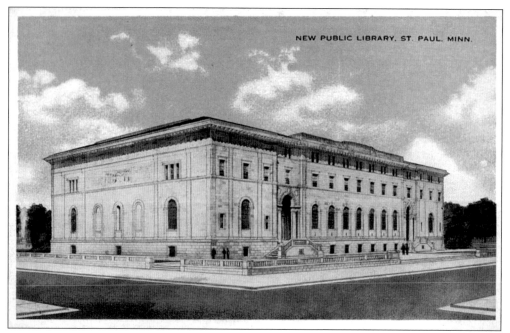

THE NEW PUBLIC LIBRARY, ON FOURTH STREET ACROSS FROM RICE PARK, ST. PAUL, C. 1920. Built in the early-to-mid 1910s, the Public Library was presented to the city by James J. Hill. It would replace the library at Seventh and Wabasha Streets.

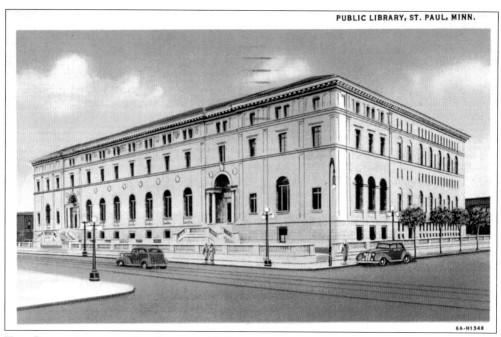

THE PUBLIC LIBRARY, ST. PAUL, C. 1940S.

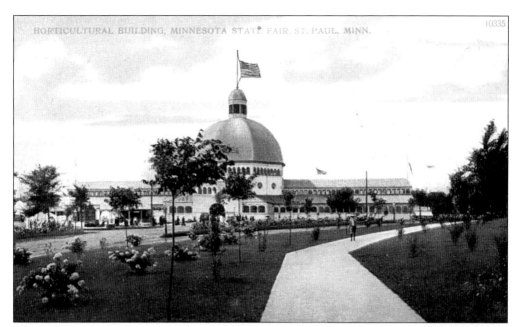

THE HORTICULTURAL BUILDING, MINNESOTA STATE FAIR, ST. PAUL, C. 1905. The name "Minnesota State Horticultural Society" was adopted in 1873. This image shows the building, which existed as early as 1900.

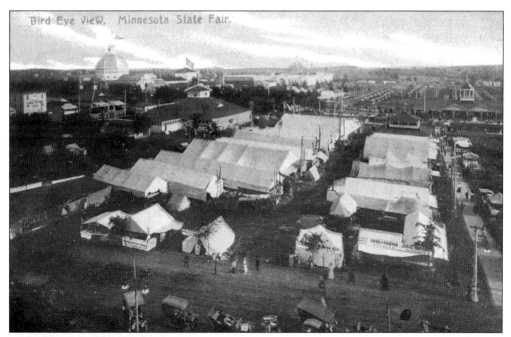

A BIRD'S-EYE VIEW OF THE MINNESOTA STATE FAIR, C. 1912. The first fair was in 1859, and during the early years moved through various sites, including stops in Red Wing, Rochester, and Winona.

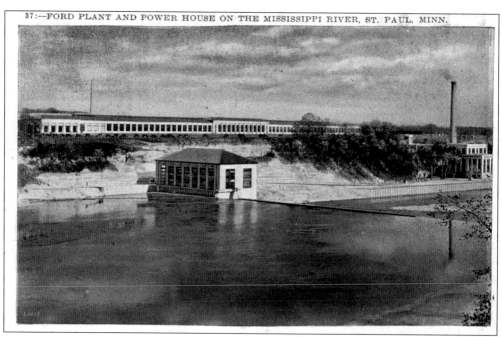

37:—FORD PLANT AND POWER HOUSE ON THE MISSISSIPPI RIVER, ST. PAUL, MINN.

THE FORD PLANT AND POWER HOUSE ON THE MISSISSIPPI RIVER, ST. PAUL.

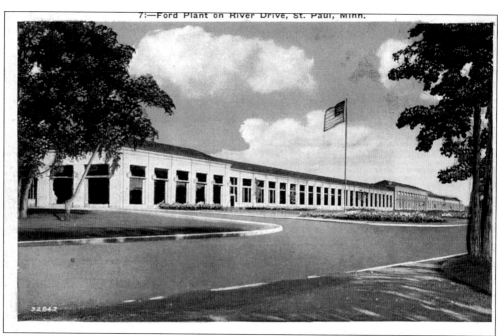

7:—Ford Plant on River Drive, St. Paul, Minn.

THE FORD PLANT ON RIVER DRIVE, ST. PAUL. The plant was constructed in the 1920s. During World War I, the plant was used to manufacture armored vehicles.

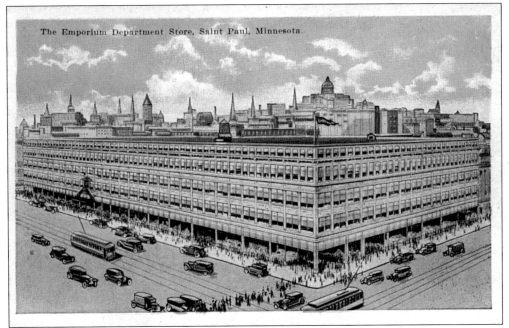

The Emporium Department Store, Saint Paul, Minnesota.

THE EMPORIUM DEPARTMENT STORE, AT SEVENTH AND ROBERT STREETS, ST. PAUL.
From the late 1910s until it closed in the late 1960s—a victim of urban sprawl and shopping malls—the Emporium was a fixture at this busy downtown intersection, opposite the Golden Rule. Today, the building is known as Metro Square. If you notice, there are no less then ten church steeples and what appears to be the Capitol Building in the background. This is an excellent example of postcard image trickery.

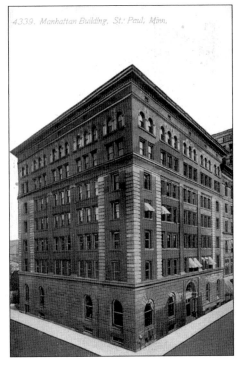

4339. Manhattan Building, St. Paul, Minn.

MANHATTAN BUILDING, LOCATED ON ROBERT STREET, ST. PAUL. Built in 1889, the structure became the Empire Building during the 1930s.

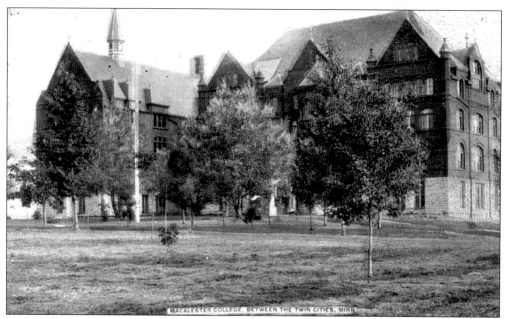

MACALESTER COLLEGE, BETWEEN THE TWIN CITIES, MINNESOTA. Founded in 1874, the college opened at its present site in 1885.

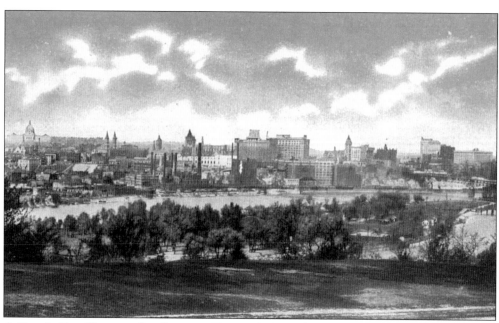

A BIRD'S-EYE VIEW OF ST. PAUL, C. EARLY 1910s. This image shows St. Paul as seen from across the Mississippi River, with Harriet Island in the foreground. The tallest buildings at the time included the Hotel St. Paul and Lowry Building.

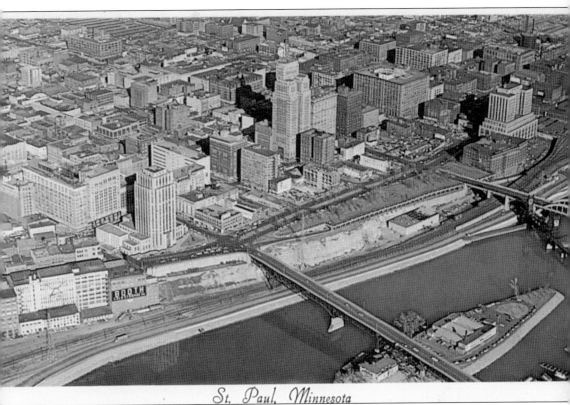

St. Paul, Minnesota

ST. PAUL, C. 1950S. This early chrome postcard image shows the city with the Mississippi River in foreground. Many of the vintage images presented in this book are represented. They are, from left to right, as follows: the Hotel St. Paul, the Lowry Building, City Hall and Ramsey County Courthouse, the First Bank Tower, and the United States Post Office. The large seven-story structure in the upper left is the Rossmor Building (originally Foot, Schulze and Company). Similar to several buildings in Lowertown, the Rossmor was converted to artists' studios on most of the upper levels. On the street level, the old structure was converted to accommodate many businesses including Keys Restaurant and Trikkx Nightclub, both having long served the community.

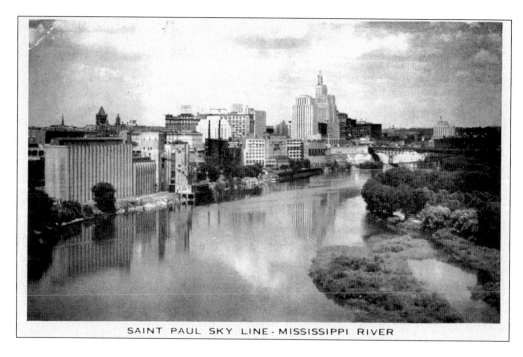

SAINT PAUL SKY LINE - MISSISSIPPI RIVER

VIEWS OF THE SAINT PAUL SKYLINE AND MISSISSIPPI RIVER FROM THE NORTH AND SOUTH, C. 1950.

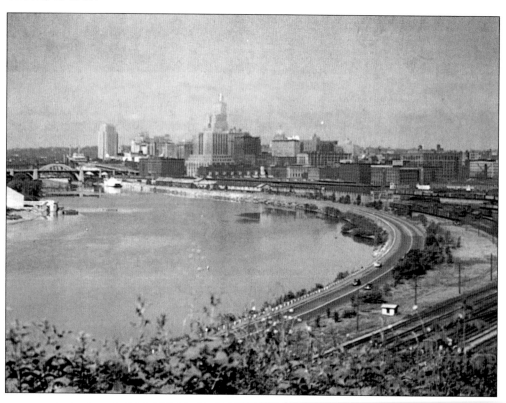

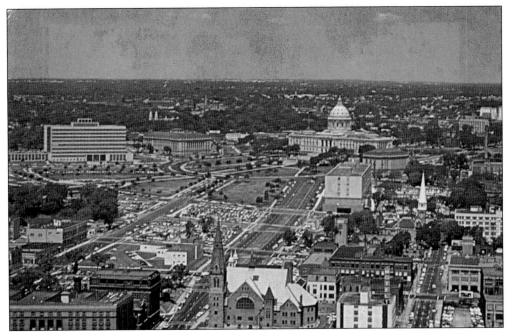

A BIRD'S-EYE VIEW OF MINNESOTA'S STATE CAPITOL, *C.* LATE 1950S–EARLY 1960S. This view from the air was taken before construction of Interstate 94 that forever divided the State Capitol and Downtown area of St. Paul. The Minnesota Historical Society Building is visible in the upper left of this image. In the center foreground, can be seen the Central Presbyterian Church on Cedar Street, built in the late 1800s.

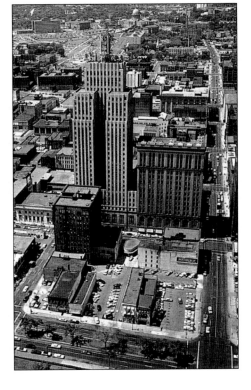

AN AIR-VIEW WITH FIRST NATIONAL BANK BUILDING, ST. PAUL. Here is another unique air-view looking up Robert Street from the south. The entire block in the foreground, which includes the Germania-Guardian Life Insurance building, was demolished and replaced by what is now known as Kellogg Square Apartments (where this author lived upon first moving to the Twin Cities in 1994).

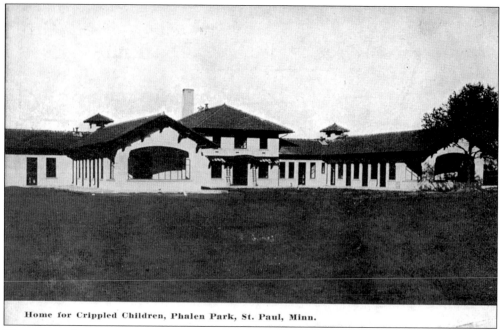

Home for Crippled Children, Phalen Park, St. Paul, Minn.

HOME FOR CRIPPLED CHILDREN, LOCATED ON IVY STREET BETWEEN FOREST AND EARL STREETS, PHALEN PARK, ST. PAUL, C. EARLY 1900S. This would become the Gillette's Children Hospital. Only one of the buildings was saved and is currently used by the Humanities Commission of Minnesota. This image shows only one of the numerous buildings that made up the hospital.

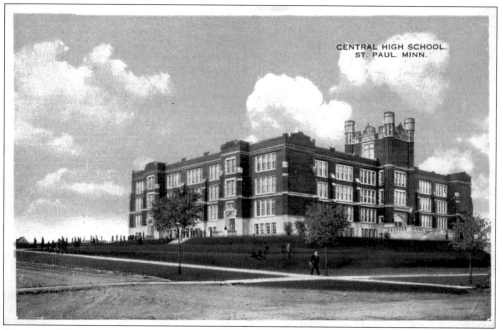

CENTRAL HIGH SCHOOL, ST. PAUL, C. EARLY 1900S. This postcard image shows "one of St. Paul's four magnificent high schools, Hill district."

Six

AROUND THE CITY
MINNEAPOLIS

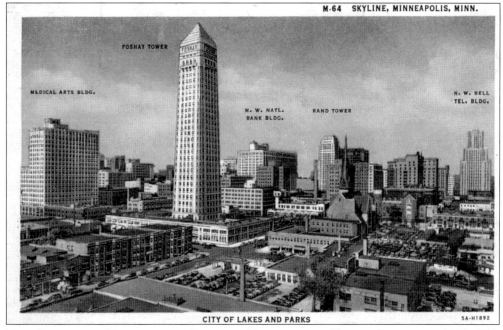

M-64 SKYLINE, MINNEAPOLIS, MINN.

FOSHAY TOWER

MEDICAL ARTS BLDG.

N. W. NATL.
BANK BLDG.

RAND TOWER

N. W. BELL
TEL. BLDG.

CITY OF LAKES AND PARKS 5A-H1892

THE SKYLINE OF MINNEAPOLIS, LOOKING NORTH FROM TENTH STREET, C. 1930. This Skyline view shows, from left to right, the Medical Arts Building, the Foshay Tower, the N.W. National Bank Building, the Rand Tower, and N.W. Bell Telephone Building.

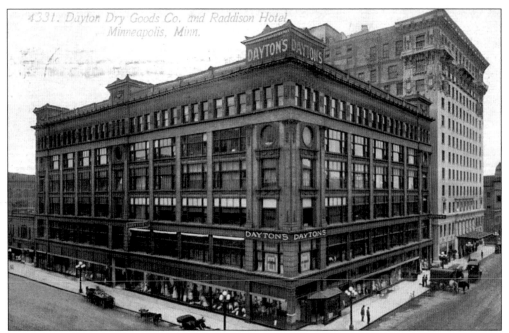

DAYTON DRY GOODS CO. AND RADISSON HOTEL, MINNEAPOLIS, C. 1911. George Dayton opened the dry goods store in 1902.

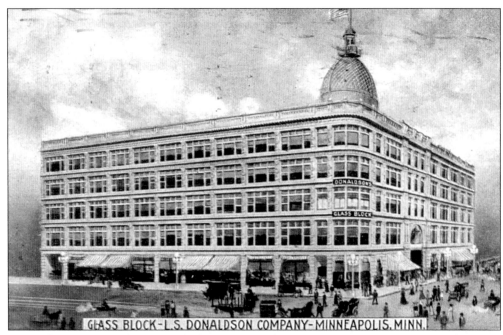

GLASS BLOCK, L.S. DONALDSON COMPANY, AT SIXTH STREET AND NICOLLET AVENUE, MINNEAPOLIS. Built in the early 1880s, this building, along with Northwestern Bank, were destroyed by fire on Thanksgiving Day in 1982. Most folks agree that it was in front of Donaldson's that Mary Tyler Moore threw her hat in 1970.

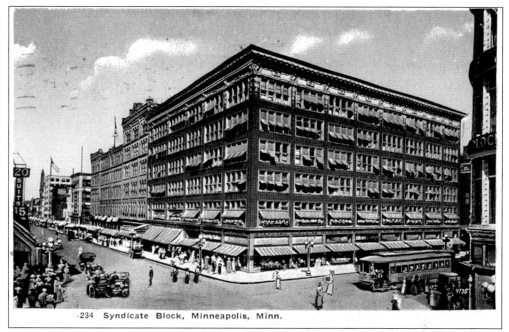

·234 Syndicate Block, Minneapolis, Minn.

SYNDICATE BLOCK, ON NICOLLET AVENUE EXTENDING FROM FIFTH TO SIXTH STREETS, MINNEAPOLIS. The large building was devoted to stores on the ground level and physicians' offices on the upper floors. This image was postmarked from Minneapolis in 1916, and shows the new facade after the 1911 fire. Demolished in 1989, today the site is occupied by the Dain Tower.

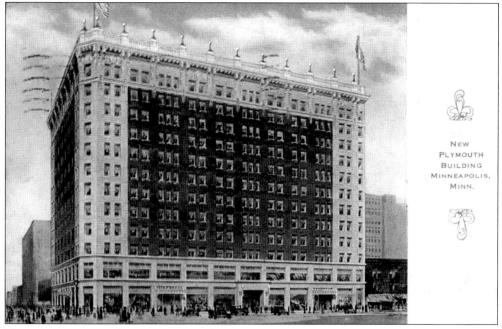

NEW
PLYMOUTH
BUILDING
MINNEAPOLIS,
MINN.

NEW PLYMOUTH BUILDING, AT SIXTH AND HENNEPIN STREETS, MINNEAPOLIS. Constructed around 1910, the building still stands today.

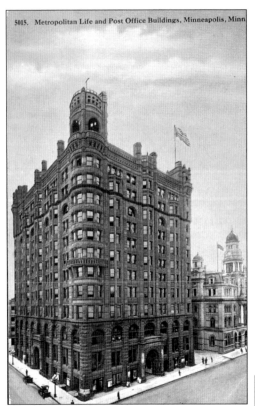

5015. Metropolitan Life and Post Office Buildings, Minneapolis, Minn

METROPOLITAN LIFE AND POST OFFICE BUILDINGS, NEAR THIRD STREET AND SECOND AVENUE MINNEAPOLIS, C. 1910s. Constructed in the 1880s, the Metropolitan Life Building became a victim of urban renewal in Minneapolis. Despite public outcry to save the building, the structure suffered the fate of the wrecking ball in late 1961.

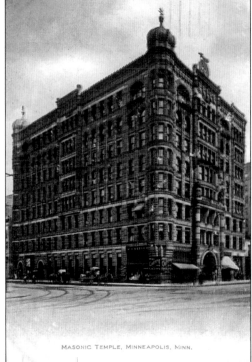

MASONIC TEMPLE, MINNEAPOLIS, MINN.

MASONIC BUILDING, HENNEPIN AND SIXTH STREETS, MINNEAPOLIS. Built in the late 1880s, today it houses the Hennepin Center for the Arts (which includes the Illusion Theatre).

CITY HALL AND COURT HOUSE, MINNEAPOLIS, C. 1909. Built between the late 1890s and early 1900s, it replaced the original City Hall, which was built in 1873. The structure is still in use today.

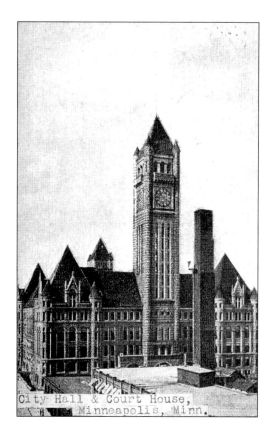

City Hall & Court House, Minneapolis, Minn.

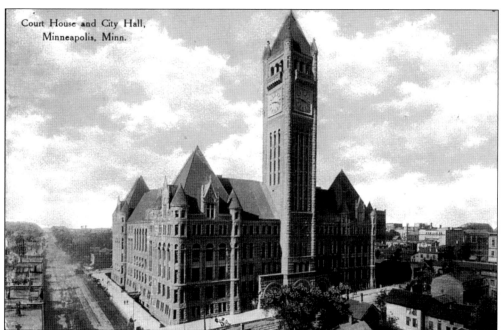

Court House and City Hall, Minneapolis, Minn.

COURT HOUSE AND CITY HALL, MINNEAPOLIS, C. 1910.

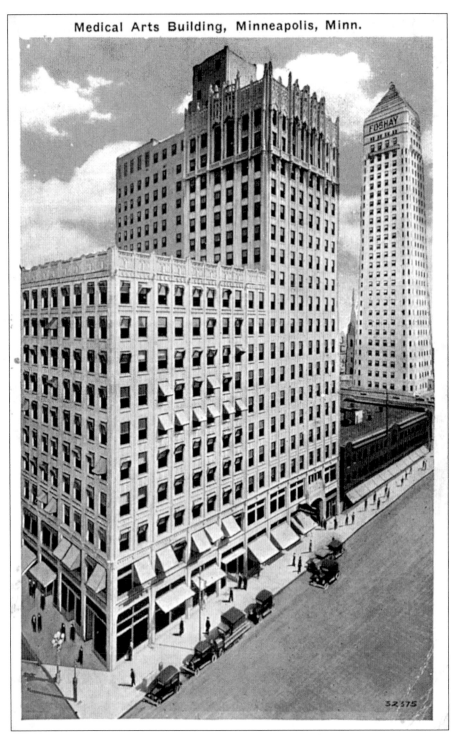

Medical Arts Building, Minneapolis, Minn.

MEDICAL ARTS BUILDING, NICOLLET AVENUE AND NINTH STREET, MINNEAPOLIS. Built around 1930, the 19-story building remains part of the city landscape (as does the Foshay Tower in the background).

FOSHAY TOWER, LOOKING NORTH ON MARQUETTE AVENUE, MINNEAPOLIS. The Rand Tower is in the background. Both buildings still stand today.

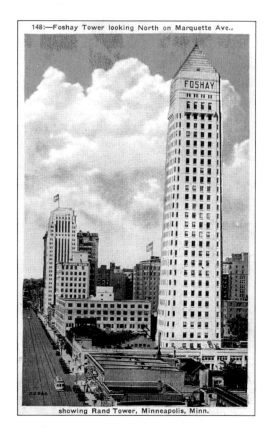

148:—Foshay Tower looking North on Marquette Ave., showing Rand Tower, Minneapolis, Minn.

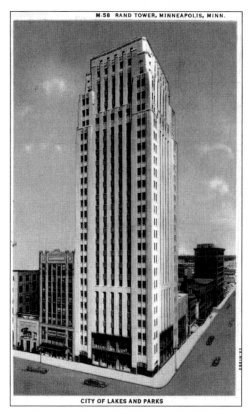

M-58 RAND TOWER, MINNEAPOLIS, MINN.

CITY OF LAKES AND PARKS

RAND TOWER, MINNEAPOLIS, C. 1930S. The Rand Tower was built in the mid 1920s.

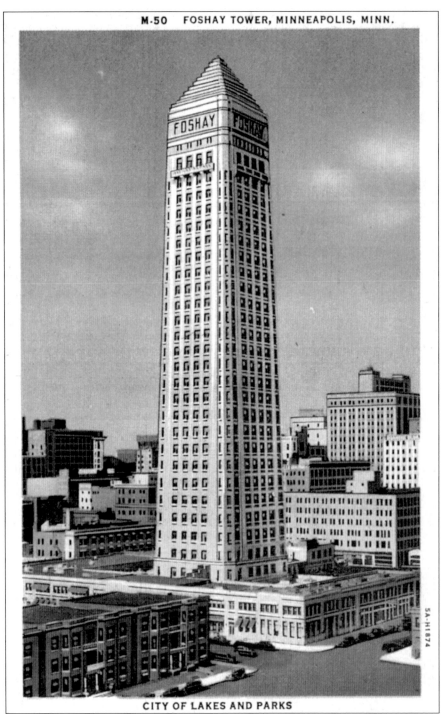

CITY OF LAKES AND PARKS

FOSHAY TOWER, MINNEAPOLIS. Built in the late 1920s, the building remained the city's tallest (with 30 floors) for 42 years until the IDS tower was built. Wilbur Foshay hired John Phillip Sousa to play at the grand opening gala. In 1978, the tower was named to the National Register of Historic Places.

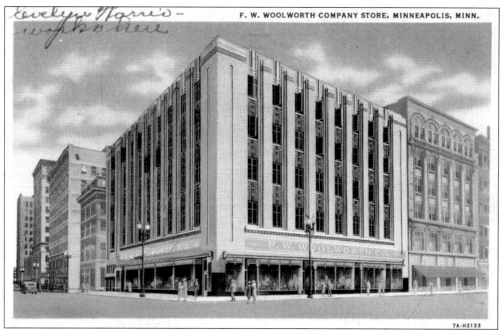

7A-H2133

F.W. WOOLWORTH COMPANY STORE, MINNEAPOLIS, C. 1938. Named for Frank Woolworth (1852–1919), one of the original "Five and Dime" stores, this five-story building was anchored at the site now home to the IDS tower. The interesting hand-written note on the front reads: "Evelyn Harris works here. Coincidentally, architect Cass Gilbert (1859–1934), the same Gilbert that designed Minnesota's State Capitol, designed the New York City Woolworth Building."

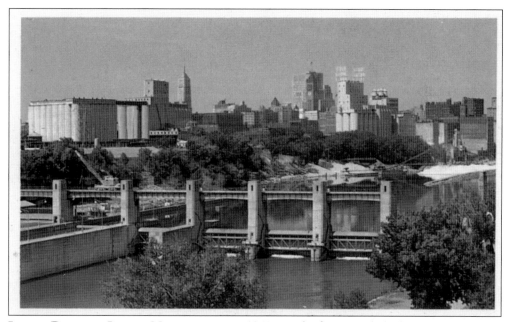

LOWER DAM AND LOCKS, MINNEAPOLIS, C. 1960s. In the foreground, the lower dam and locks are part of the Mississippi Harbor Redevelopment. The background offers a view of the city skyline with Foshay Tower.

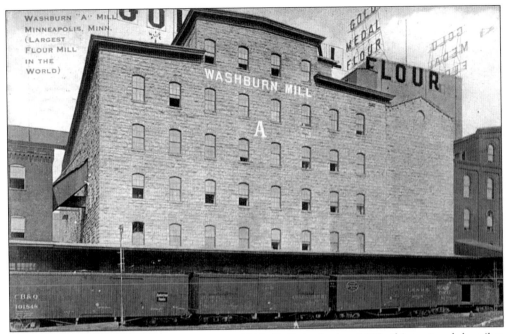

WASHBURN "A" MILL, MINNEAPOLIS, C. 1915. Built in the late 1800s this postcard describes the building as "the largest flour mill in the world." Overlooking St. Anthony Falls, the mill damaged by fire is currently part of a major redevelopment project.

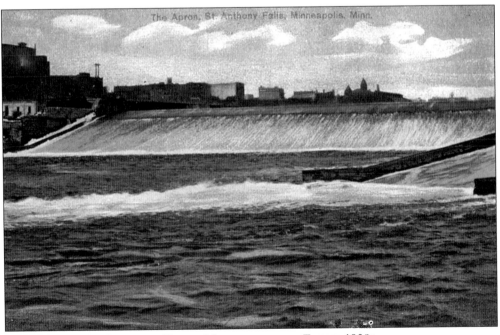

THE APRON, ST. ANTHONY FALLS, MINNEAPOLIS, C. EARLY 1900S.

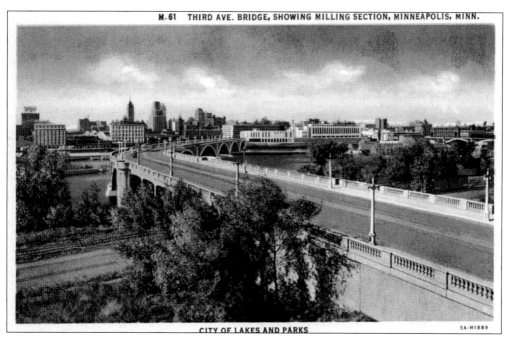

THIRD AVENUE BRIDGE, SHOWING MILLING SECTION, MINNEAPOLIS, C. 1930S.

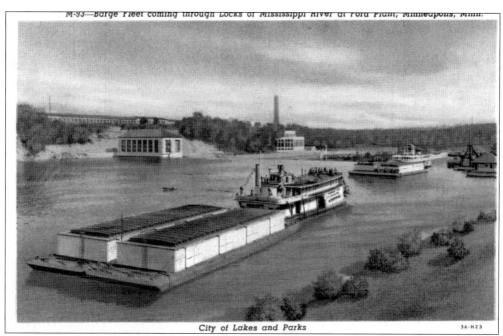

A BARGE FLEET COMING THROUGH THE LOCKS OF THE MISSISSIPPI RIVER AT FORD PLANT, MINNEAPOLIS, C. 1930S.

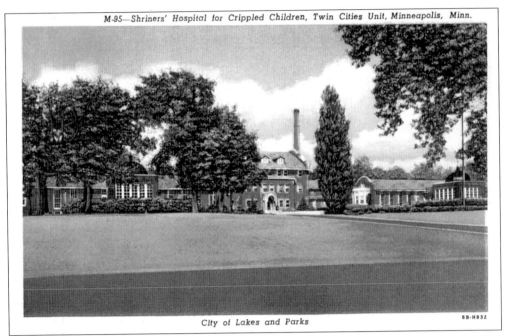

City of Lakes and Parks

8B-H932

SHRINERS HOSPITAL FOR CRIPPLED CHILDREN, TWIN CITIES UNIT, MINNEAPOLIS. The postcard indicates "the unit was opened in 1923 for the benefit of crippled children whose parents cannot afford to pay for treatment. All patients are admitted without regard to race, creed or color."

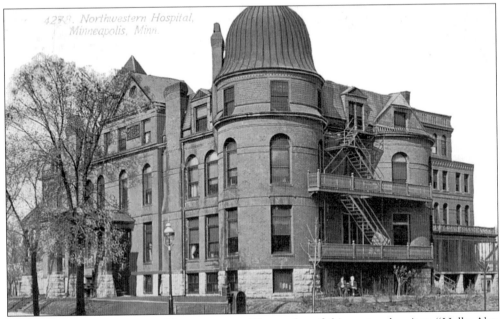

4278. Northwestern Hospital, Minneapolis, Minn.

NORTHWESTERN HOSPITAL, MINNEAPOLIS. The sender of this postcard writes: "Hello Abe, Still alive I hope." It was postmarked from Minneapolis in 1911.

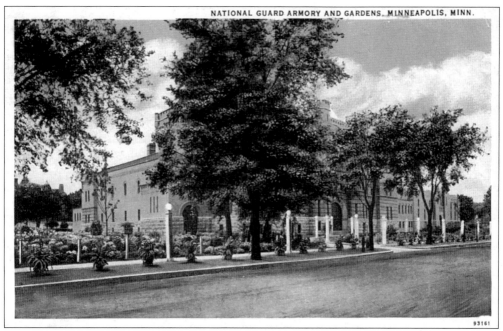

93161

THE NATIONAL GUARD ARMORY AND GARDENS, MINNEAPOLIS. This postcard appears to be pre-1935, which is when the Armory (as seen in the next image) was built. Since the two images appear quite different, this would likely be the first Armory?

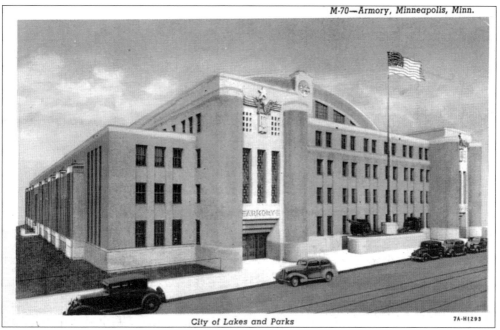

M-70—Armory, Minneapolis, Minn.

City of Lakes and Parks

7A-H1293

THE ARMORY, MINNEAPOLIS. Built around 1935, and in use until the late 1970s, the Armory is now an indoor parking garage of sorts as the building is on the National Register of Historic Places.

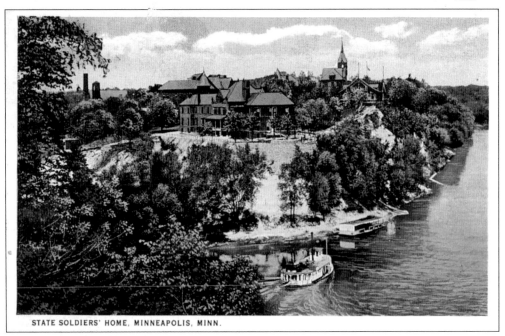

STATE SOLDIERS' HOME, MINNEAPOLIS, MINN.

STATE SOLDIERS HOME, MINNEAPOLIS, C. 1920. The home was built *c.* 1904 on 50 acres near the Mississippi River and Minnehaha Creek.

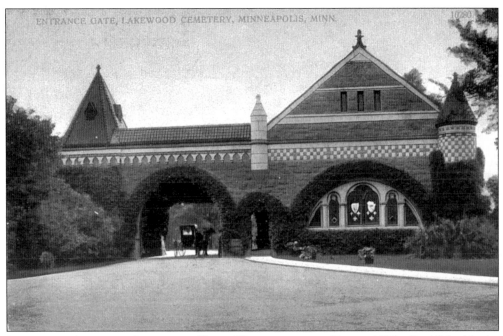

ENTRANCE GATE, LAKEWOOD CEMETERY, MINNEAPOLIS, MINN.

LAKEWOOD CEMETERY ENTRANCE GATE, MINNEAPOLIS, C. EARLY 1900S. Established in the early 1860s, the cemetery burials include Hubert Humphrey Jr. (1911–1978) and John S. Pillsbury (1827–1901).

Wesley Temple Building, Located on East Grant Street, Minneapolis. In 1928, ground was broken on this 12-story community center. When completed, the buildings housed offices, entertainment venues (including a bowling alley), even the offices of WTCN Radio. In the late 1980s, the building was demolished to make way for the Minneapolis Convention Center.

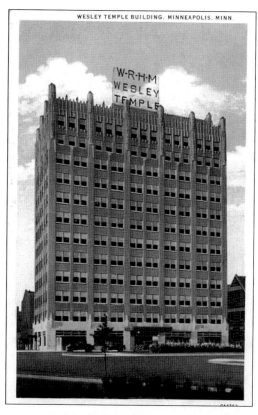

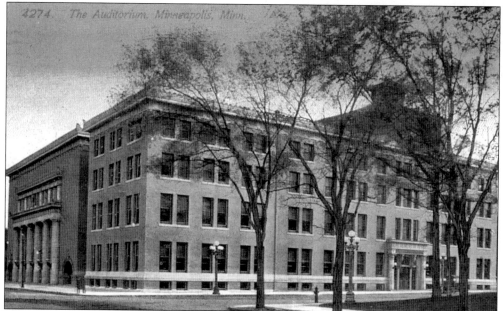

THE ORIGINAL AUDITORIUM, AT ELEVENTH STREET AND NICOLLET AVENUE, MINNEAPOLIS, C. 1910–1915. Opened in 1905 at Eleventh Street and Nicollet, the auditorium became the Lyceum Theater in later years, after a new auditorium was built.

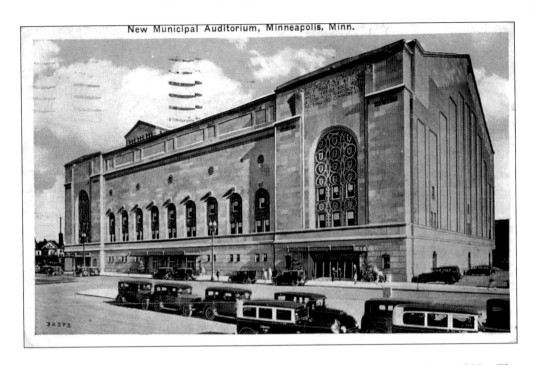

New Municipal Auditorium, Minneapolis, Minn.

THE NEW MUNICIPAL AUDITORIUM, GRANT STREET, MINNEAPOLIS, C. LATE 1930s. The new auditorium, built at a cost of more than $3 million in the late 1920s, was home to the Minneapolis Lakers from the late 1940s to about 1960. The auditorium featured 88,000 feet of exhibition space. It played host to many musical concerts including Jimi Hendrix in 1968 and U2 in 1985 (to the best of the writer's knowledge).

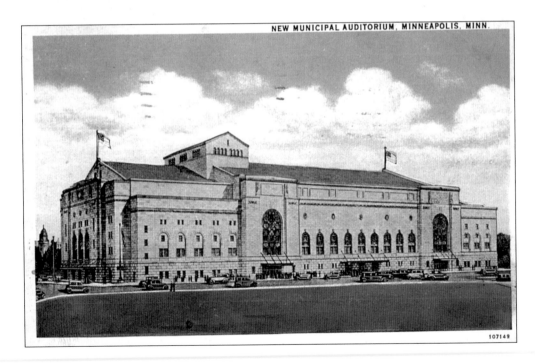

NEW MUNICIPAL AUDITORIUM, MINNEAPOLIS, MINN.

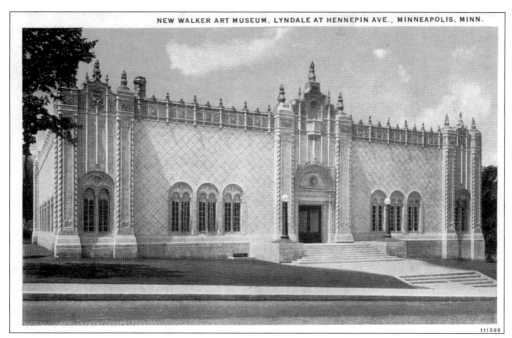

THE NEW WALKER ART MUSEUM, LOCATED ON LYNDALE AT HENNEPIN AVENUE, MINNEAPOLIS, C. 1930. This image shows the recently constructed Museum.

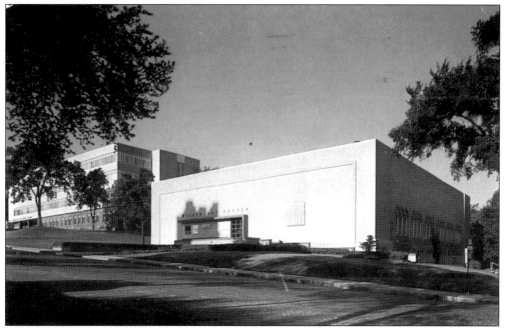

WALKER ART CENTER AND NORTH AMERICAN LIFE AND CASUALTY BUILDING, MINNEAPOLIS, C. 1950S. Here is a more modern image.

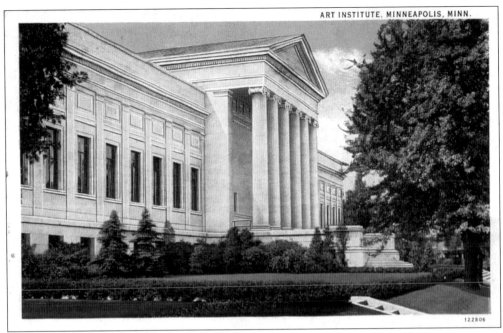

122806

ART INSTITUTE, MINNEAPOLIS. The building was constructed in the early 1910s.

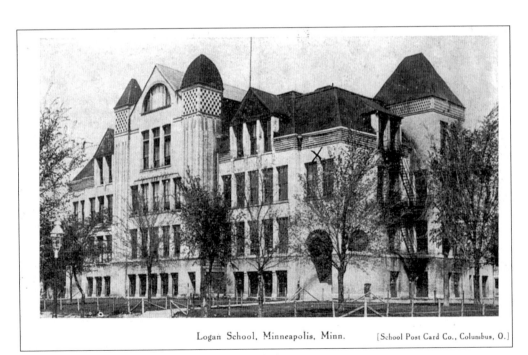

Logan School, Minneapolis, Minn. [School Post Card Co., Columbus, O.]

LOGAN SCHOOL, MINNEAPOLIS, C. EARLY 1900S.

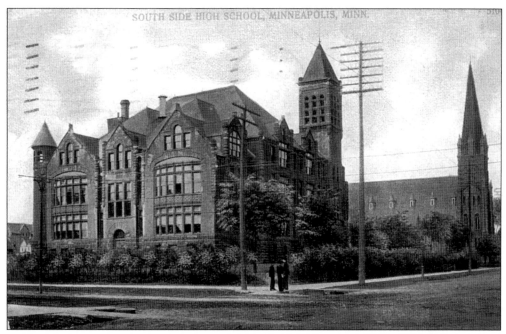

SOUTH SIDE HIGH SCHOOL, MINNEAPOLIS. This card was postmarked from Minneapolis in 1910.

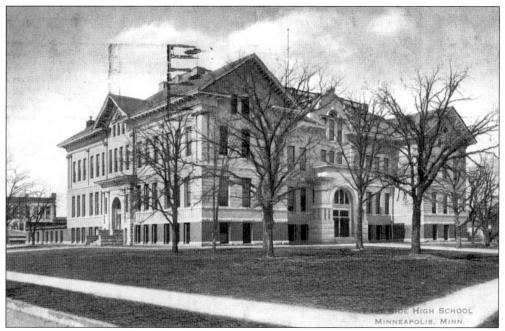

EAST SIDE HIGH SCHOOL, MINNEAPOLIS. Another learning institution in the city, this image dates to the 1910s.

I shall be glad to accomadate you. I will write to you as soon as I get a chance. Lovingly Lucile.

Dear Agnes; I think you must have asked a favor of some kind of me in your letter, but you neglected to send the first page of the letter. If you send it

CAMPUS VIEW (PILLSBURY HALL ON LEFT), UNIVERSITY OF MINNESOTA. This postcard is postmarked 1907, which means this image is from the turn of the century. Pillsbury Hall was built in the late 1880s in part through the vision and support of John S. Pillsbury. Still in use today, the building is also listed on the National Register of Historic Places.

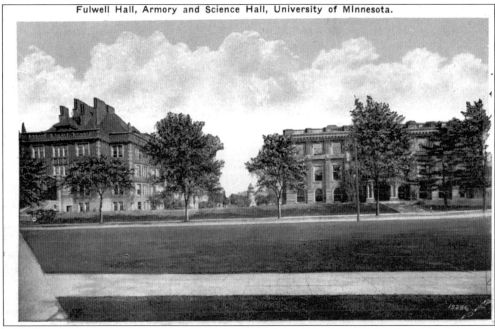

Fulwell Hall, Armory and Science Hall, University of MInnesota.

FULWELL HALL, ARMORY, AND SCIENCE HALL, UNIVERSITY OF MINNESOTA, C. EARLY 1910s. This building is still standing and in use today.

Seven

LAKES AND PARKS

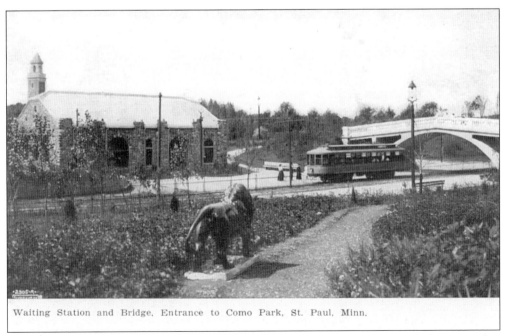

Waiting Station and Bridge, Entrance to Como Park, St. Paul, Minn.

WALKING STATION AND BRIDGE, ENTRANCE TO COMO PARK WITH STREETCAR, ST. PAUL. Como Park development began as early as the late 1800s.

Rustic Bridge at Loring Park, Minneapolis. Originally known as Central Park and through the years referred to as Jewett's Park and Johnson's Lake, the park took on the name Loring sometime in the 1890s for Charles Loring, father of the Minneapolis Park System. The park today remains an active gathering spot and has been annual host to the Twin Cities GLBT Pride Festival each June. This image was postmarked 1913.

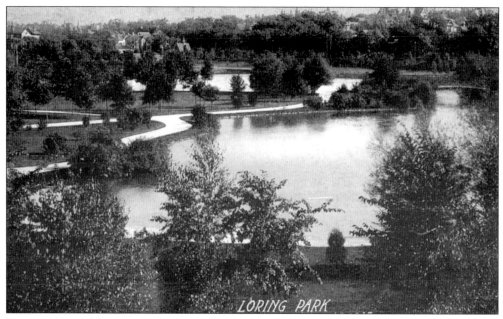

Loring Park, Minneapolis.

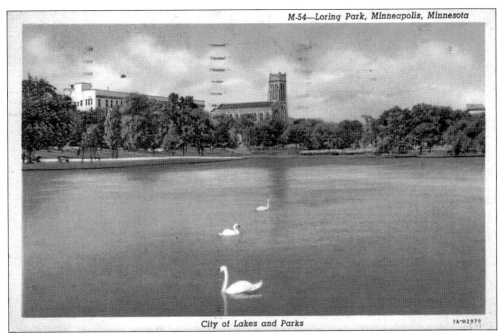

LORING PARK, MINNEAPOLIS, *C.* LATE 1930s. This image shows Hennepin Methodist Church in center background.

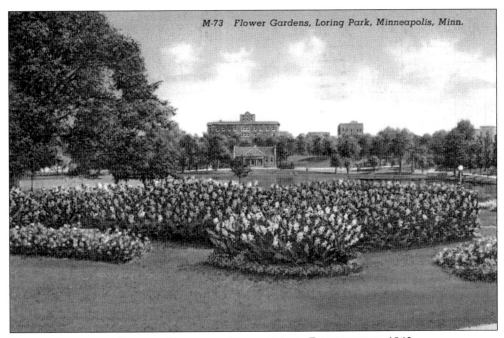

LORING PARK AND FLOWER GARDENS, MINNEAPOLIS, POSTMARKED 1942.

LORING PARK WITH FOSHAY TOWER IN BACKGROUND, MINNEAPOLIS, C. 1960. In October of 1998, a vigil was held in the park for Matthew Shepard.

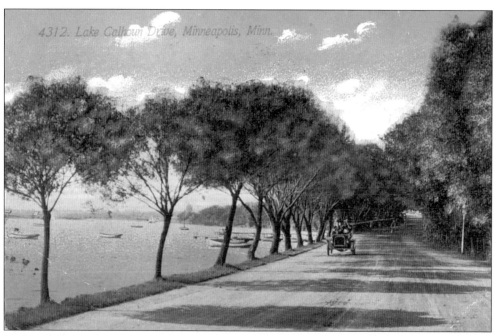

LAKE CALHOUN DRIVE, MINNEAPOLIS, POSTMARKED 1910. Lake Calhoun, in the Minneapolis Uptown area, continues to serve as a popular location for recreation and leisure. Most of the Minneapolis lakes were developed and expanded in the early 1900s, largely in part through the vision of Theodore Wirth, Superintendent of Parks.

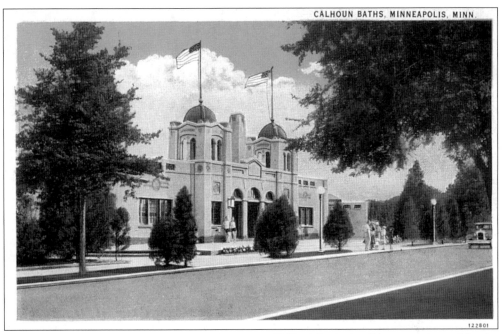

THE CALHOUN BATHS, MINNEAPOLIS, IMAGE C. 1910S. The baths did not survive and by the early 1950s were closed before being demolished.

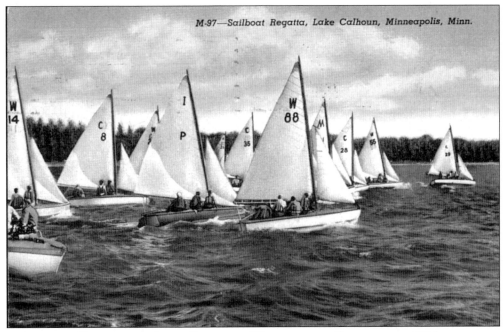

M-97—Sailboat Regatta, Lake Calhoun, Minneapolis, Minn.

A SAILBOAT REGATTA AT LAKE CALHOUN, MINNEAPOLIS, POSTMARKED 1954.

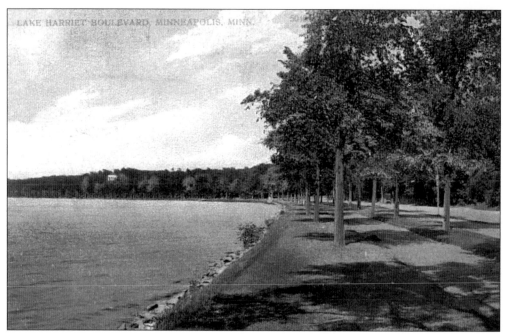

LAKE HARRIET BOULEVARD, MINNEAPOLIS, C. EARLY 1900S.

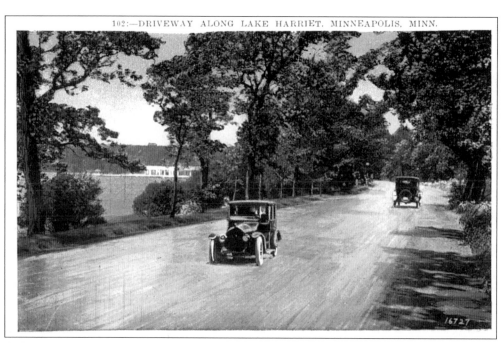

A DRIVEWAY ALONG LAKE HARRIET, MINNEAPOLIS, C. EARLY 1900S. The early roads and walkways around the lakes were almost all dirt in the early 1900s. Through the 1910s and into the 1920s many were paved. Most of the lakes were dredged and filled at the same time.

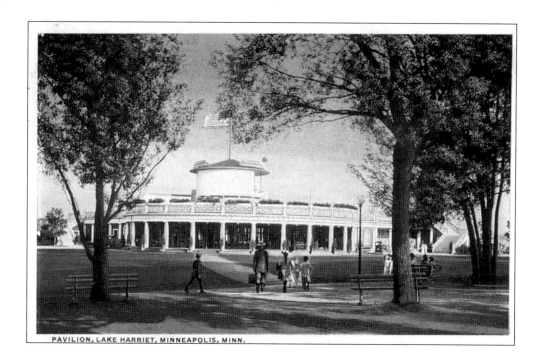

PAVILION, LAKE HARRIET, MINNEAPOLIS, MINN.

PAVILIONS AT LAKE HARRIET, MINNEAPOLIS. These images from the early 1900s to about 1915 capture two (most likely different) Pavilions' at the popular lake. Various pavilions, bandstands, and refectories came and went, many lost to storms and harsh weather. Today, Lake Harriet is still a popular spot for music played at the bandshell (or Pavilion if you wish).

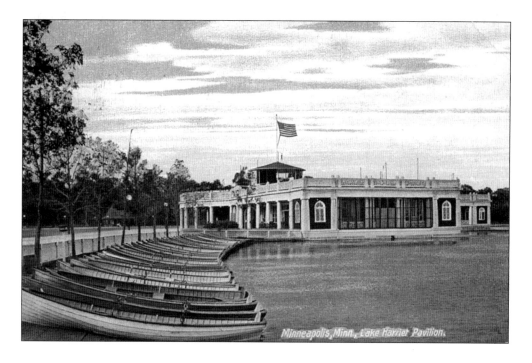

Minneapolis, Minn., Lake Harriet Pavilion.

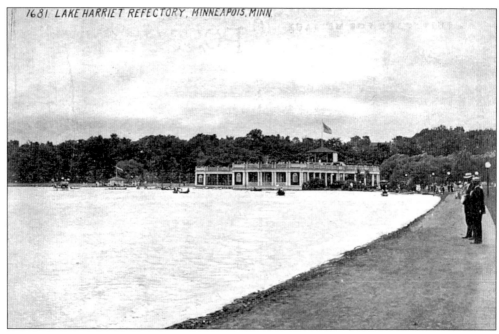

LAKE HARRIET REFECTORY, MINNEAPOLIS, C. EARLY 1900S. Here is another beautiful image from the early 1900s. Notice the gentlemen dressed in suits with top hats.

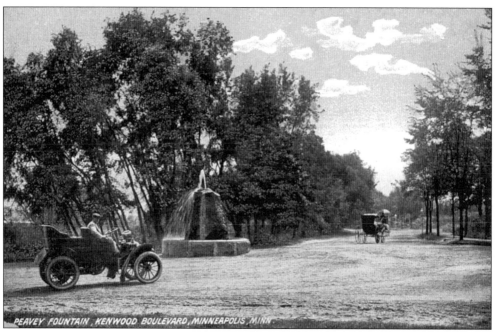

PEAVEY FOUNTAIN, KENWOOD BOULEVARD, MINNEAPOLIS, C. EARLY 1900S.

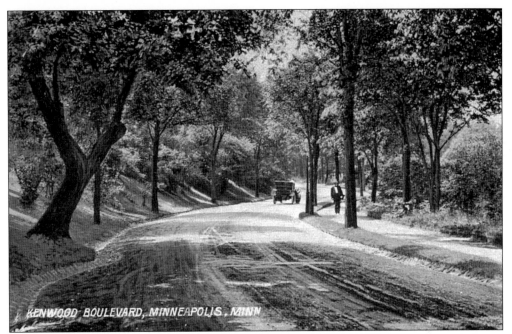

KENWOOD BOULEVARD, MINNEAPOLIS. A well-suited gentleman strolls along the roadside as a single automobile passes him by in this turn-of-the-century view.

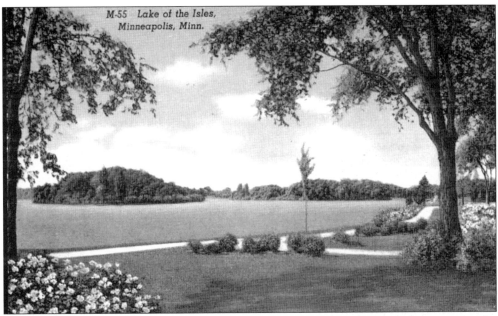

LAKE OF THE ISLES, MINNEAPOLIS. Beautiful homes surround the lake where Mary Tyler Moore (a.k.a. Mary Richards) took a happy stroll for the opening of her television program.

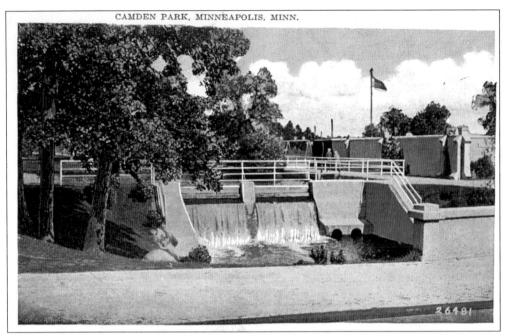

CAMDEN PARK, MINNEAPOLIS, MINN.

CAMDEN PARK, MINNEAPOLIS. Supposedly, this park was named after Camden, New Jersey.

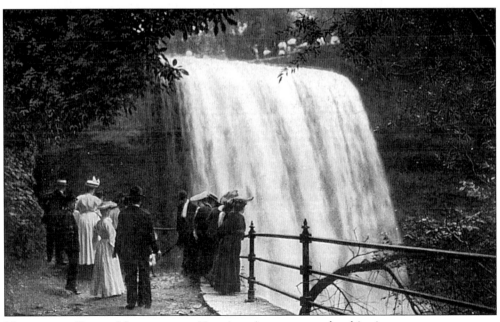

MINNEHAHA FALLS, MINNEAPOLIS. Here is an image encapsulated in time.

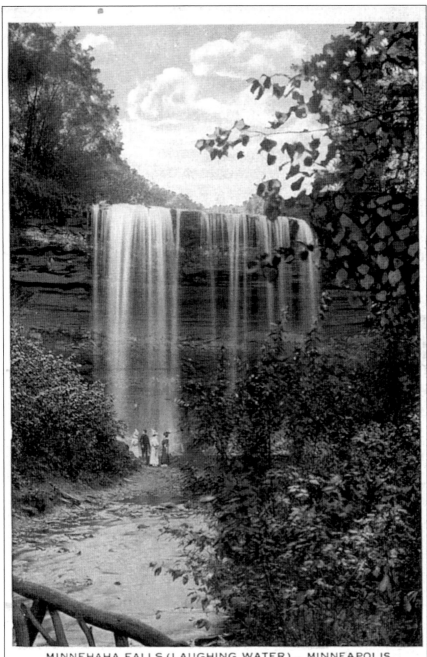

MINNEHAHA FALLS (LAUGHING WATER) — MINNEAPOLIS.
"WHERE THE FALLS OF MINNEHAHA
FLASH AND GLEAM AMONG THE OAK TREES
LAUGH AND LEAP INTO THE VALLEY" —*Longfellow's Hiawatha.*
The Burlington is the scenic line between Chicago and St. Paul — Minneapolis.

MINNEHAHA FALLS, (LAUGHING WATERS), MINNEAPOLIS. "Where the Falls of Minnehaha Flash and gleam among the oak trees Laugh and leap into the valley. And he named her for the river, From the water-fall he named her Minnehaha, Laughing Water."—Longfellow's Hiawatha. Take a close look at the well-dressed ladies and man standing below at the falls.

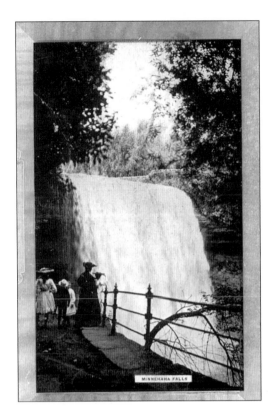

MINNEHAHA FALLS, MINNEAPOLIS, NEAR THE TURN OF THE CENTURY.

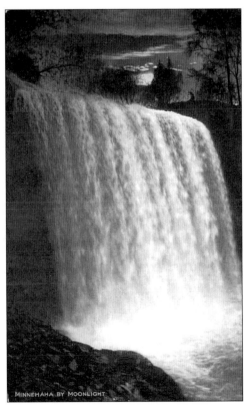

MINNEHAHA BY MOONLIGHT, C. EARLY 1900s.

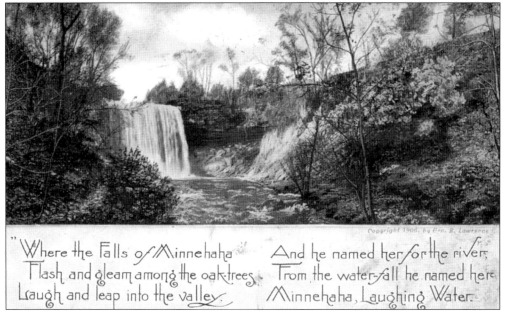

"Where the Falls of Minnehaha And he named her for the river,
Flash and gleam among the oak-trees; From the water-fall he named her
Laugh and leap into the valley. Minnehaha, Laughing Water.

MINNEHAHA FALLS. There must be one hundred or more postcards from the early 1900s representing the falls. For this book, I have tried to select a few of the most extraordinary ones.

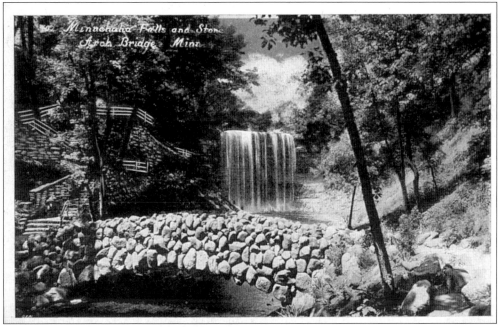

MINNEHAHA FALLS AND STONE ARCH BRIDGE, MINNEAPOLIS. From the postcard: "The most widely celebrated of Natural Curiosities of the Northwest. Longfellow's Hiawatha has made an object of the curiosity and admiration of travelers. The stone arch bridge was taken from the Gorge beneath."

113

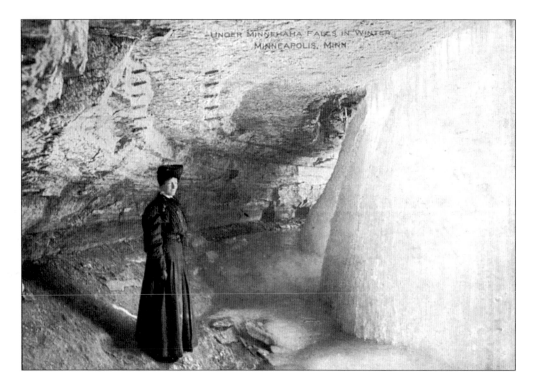

MINNEHAHA FALLS, MINNEAPOLIS. Both images of the famous falls date 1909. The winter view shows a well-dressed woman standing under the frozen falls. I cannot imagine that she is very warm.

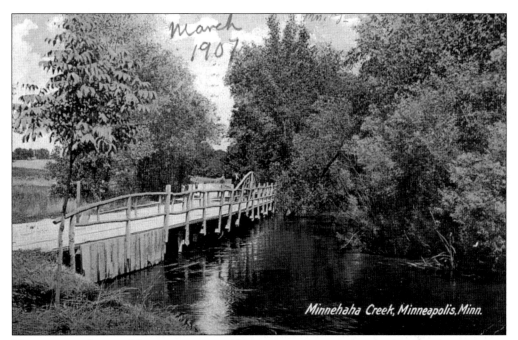

MINNEHAHA CREEK, MINNEAPOLIS, C. 1900.

"COME TAKE A RIDE," TWIN CITIES, UNKNOWN LOCATION, POSTMARKED 1909.

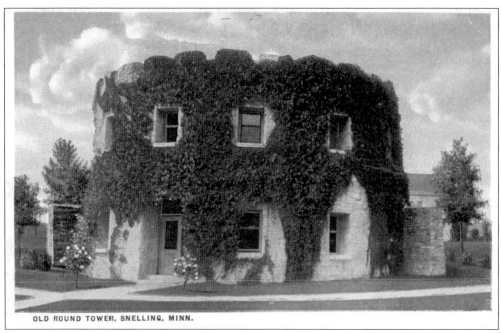

OLD ROUND TOWER, SNELLING, MINN.

OLD ROUND TOWER, SNELLING, MINNESOTA. The original fort was built around 1820 and operated as a fort until the middle 1940s. It was named for Colonel Josiah Snelling.

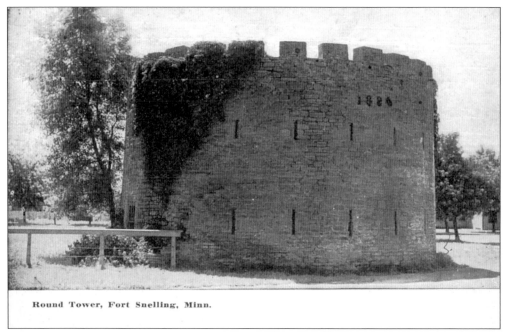

Round Tower, Fort Snelling, Minn.

ROUND TOWER, FORT SNELLING, MINNESOTA. Depending on the image you look at, the tower was either in Snelling, Fort Snelling, Minneapolis, or somewhere in between. The Round Tower became a museum in the late 1930s.

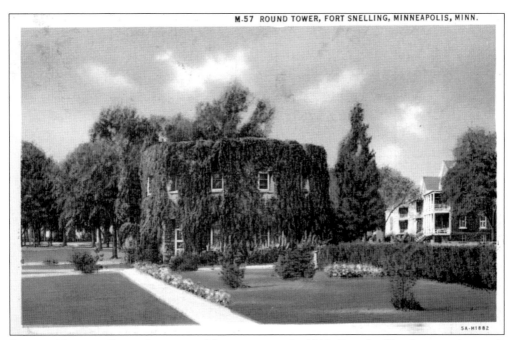

ROUND TOWER, FORT SNELLING, MINNEAPOLIS. In 1960, Fort Snelling became the state's first National Historic Landmark.

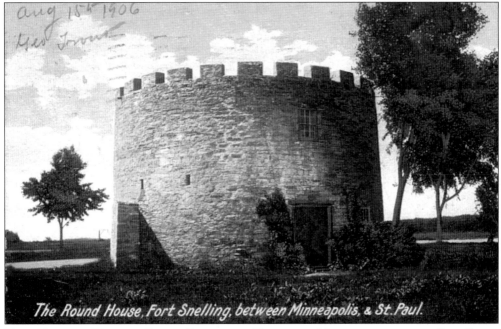

The Round House, Fort Snelling, between Minneapolis, & St. Paul.

THE ROUND HOUSE, FORT SNELLING, BETWEEN MINNEAPOLIS AND ST. PAUL, POSTMARKED 1906.

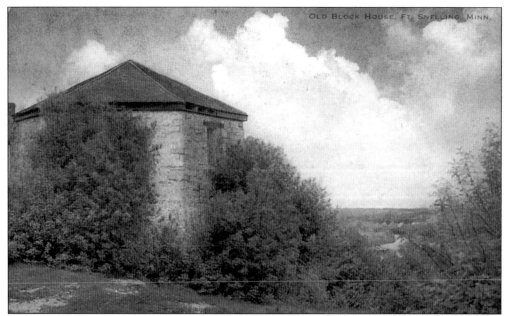

OLD BLOCK HOUSE AT FT. SNELLING, MINNESOTA, HAND DATED APRIL 27, 1916.

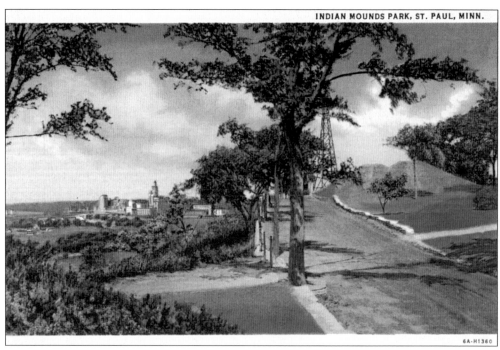

INDIAN MOUNDS PARK, ST. PAUL. The park, established in the late 1890s, still offers great views of the Mississippi River and Downtown St. Paul (the tall building in the distance is the 1st Bank Building). Only six of the original sixteen burial mounds remain.

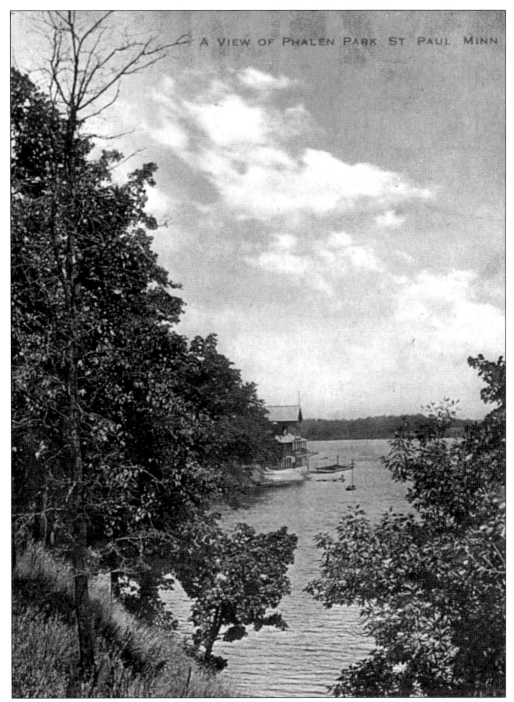

A VIEW OF PHALEN PARK, ST. PAUL, C. EARLY 1900S. This image of the tranquil setting on Lake Phalen. The lake was named for Edward Phelan (spelling of the lake and park were altered),who settled to the area in the 1840s. The lake was established as early as 1890. Nearby on Ivy Street, the Gillette Children's Hospital was established sometime near the turn of the century or early 1900s.

119

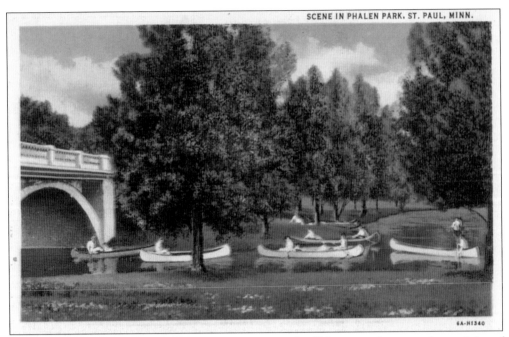

PHALEN PARK SCENE, ST. PAUL. Canoeing was, and still is, a popular recreation activity of visitors to Lake Phalen on St. Paul's East Side.

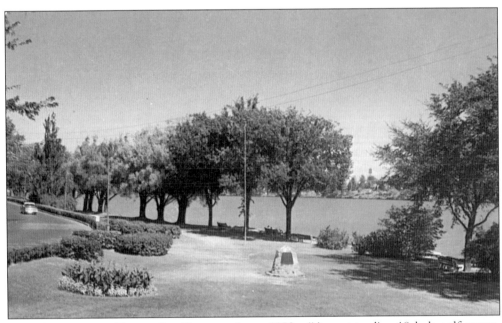

LAKE PHALEN AND DRIVE, ST. PAUL, C. LATE 1950s. "An outstanding 18-hole golf course, large picnic grounds, tennis courts are found here." The sender writes: "We go swimming here sometimes."

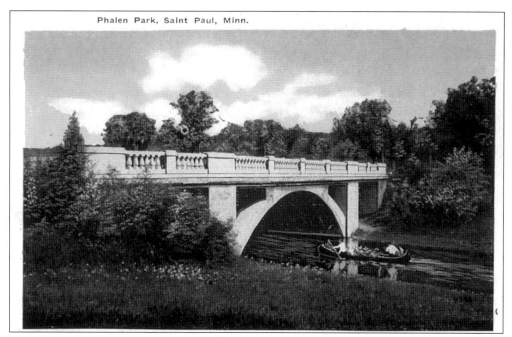

Phalen Park, Saint Paul, Minn.

PHALEN PARK, ST. PAUL. Two folks canoe the waters at Lake Phalen in the early 1900s.

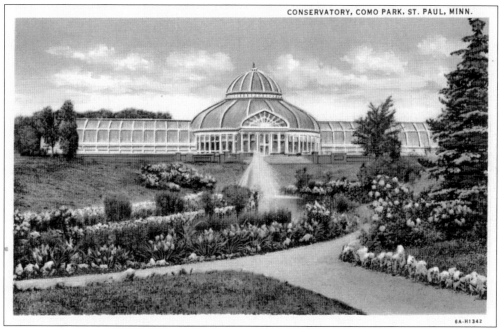

CONSERVATORY, COMO PARK, ST. PAUL, MINN.

6A-H1342

CONSERVATORY AT COMO PARK, ST. PAUL. One of the most popular recreation spots in the city, the conservatory was built about 1915 and features a domed greenhouse.

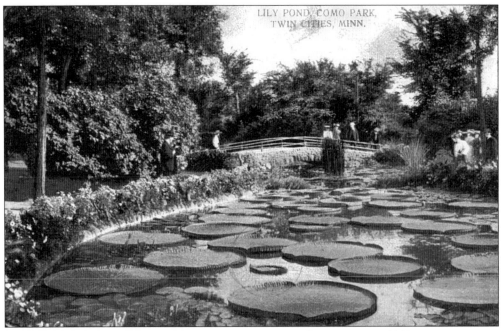

LILY POND, COMO PARK, TWIN CITIES, MINNESOTA, POSTMARKED 1908.

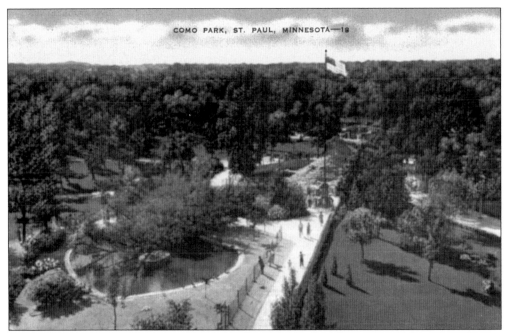

COMO PARK FROM THE AIR, ST. PAUL. "One of the most beautiful parks in the entire country, resplendent with beautiful flowers, trees and shrubbery, skillfully arranged in exquisite beauty," boasts the text of this postcard.

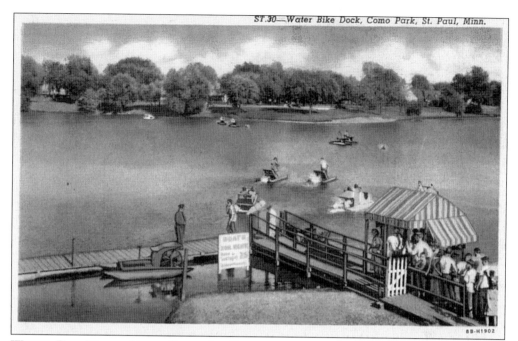

WATER BIKE DOCK, COMO PARK, ST. PAUL.

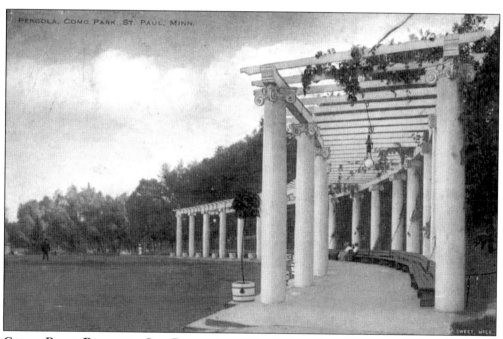

COMO PARK PERGOLA, ST. PAUL, C. 1910S. Today, the 100-acre park features a zoo, conservatory, and lakeside pavilion where one may enjoy summer concerts or bicycle and paddleboat rentals.

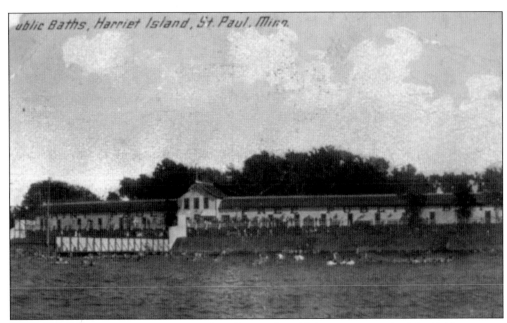

PUBLIC BATHS, HARRIET ISLAND, ST. PAUL. An old image postmarked in 1912 captures bathers at the free Public Baths. The island was originally named for Harriet E. Bishop, a St. Paul schoolteacher. Justus Ohage, a doctor and health officer in St. Paul, developed the island and park, which included a public bathhouse, beach, playgrounds, pavilions, and even a zoo. Dirty water forced closure of the beach in the early 1920s.

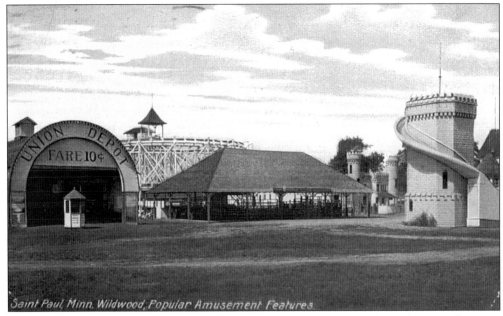

SOME POPULAR FEATURES OF WILDWOOD AMUSEMENT PARK. Although not really in St. Paul, the Wildwood Amusement Park was located on the shores of White Bear Lake, a luxurious resort built by the streetcar company. The park closed in the late 1930s and everything was later demolished.

Eight

THE THEATRE

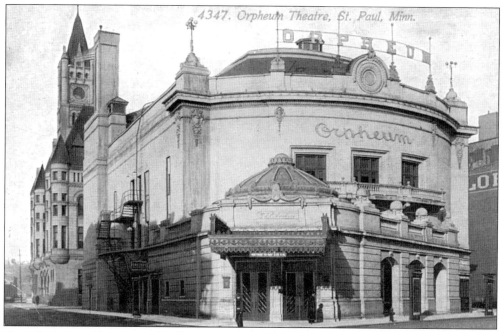

THE ORPHEUM THEATRE, ST. PAUL, C. 1912. This is the first of two Orpheum Theatres in St. Paul. This one was located at Fifth and St. Peter Streets opposite the Hotel St. Paul and Rice Park. The second Orpheum was contained within the St. Francis Hotel on Seventh Street and still is in existence today, although it has been closed for years.

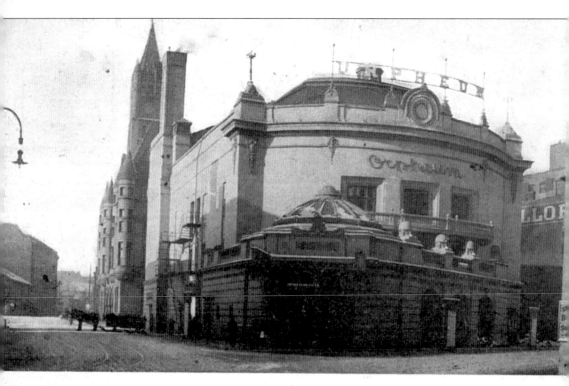

Orpheum Theatre, St. Paul.

ORPHEUM THEATRE, ST. PAUL. Another view postmarked in 1911 shows the Post Office Building behind the Theatre. A sign for the St. Paul Book and Stationary Company is visible in the lower right hand corner. The Theatre survived until the late 1930s and was subsequently demolished.

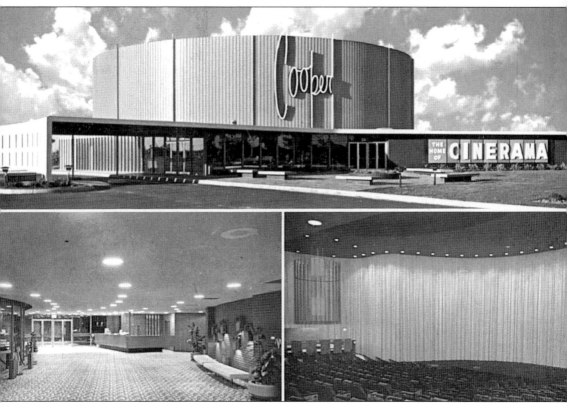

THE COOPER THEATRE, 5755 WAYZATA BOULEVARD, MINNEAPOLIS. An architectural "Symphony in the Round," the theatre opened in 1962 exclusively for the showing of Cinerama productions. After a short life, just shy of 30 years, the last movie shown was *Dances with Wolves* in 1991. This postcard was mailed from Minneapolis in 1963.

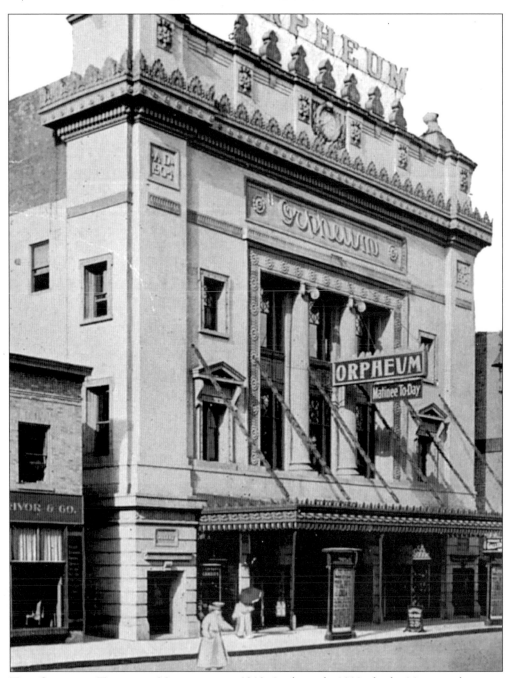

THE ORPHEUM THEATRE, MINNEAPOLIS, 1912. In the early 1900s, both cities were home to easily a dozen theatres each. Only a few survived and still operate as such today. Most vanished and a few still stand today in need of restoration. This image is of the first Orpheum in Minneapolis; it sat a few doors down from the original Radisson Hotel. It vanished from the city by the early 1940s. A second Orpheum was built on Hennepin Avenue and opened in 1921 as a silent movie house and operated as such until 1960. In the early 1990s the theatre was renovated and operates today for touring Broadway shows.